IMAGES
of America

YAZOO

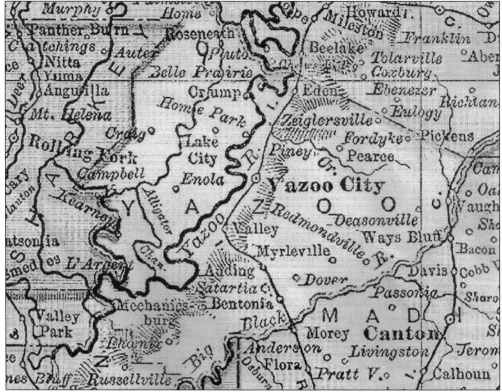

This early map of Yazoo County shows the many smaller communities and the county seat, Yazoo City, in 1895. The county had gone through numerous changes by this time, having extended all the way to the Mississippi River when it was first formed in 1823. Part or all of Madison, Sharkey, Washington, Bolivar, Sunflower, Humphries, Holmes, and Issaquena Counties were created out of Yazoo County, and by 1918, the present boundaries were established. (Courtesy of MemorialLibrary.com.)

ON THE COVER: St. Francis School students are shown leaving Ricks Memorial Library. The mission school was formed in 1940 to minister to the African American children of Yazoo City. Ricks Memorial Library, dating from 1901, is the oldest public library building in Mississippi and was the first public entity in Yazoo City to integrate its facilities in compliance with the Civil Rights Act of 1964. (Courtesy of Precious Banks.)

IMAGES
of America

YAZOO

John E. Ellzey

ARCADIA
PUBLISHING

Published by Arcadia Publishing
Charleston, South Carolina

Printed in the United States of America

Library of Congress Control Number: 2013949235

For all general information, please contact Arcadia Publishing:
Telephone 843-853-2070
Fax 843-853-0044
E-mail sales@arcadiapublishing.com
For customer service and orders:
Toll-Free 1-888-313-2665

Visit us on the Internet at www.arcadiapublishing.com

To Sam Olden, Harriet DeCell Kuykendall, and Mary Edwards Brister, whose knowledge of Yazoo's history and whose efforts to preserve our heritage have inspired me in this endeavor.

Contents

Acknowledgments 6

Introduction 7

1. Prehistory and Native Americans 9

2. Early Settlers and Communities 13

3. Civil War, Reconstruction, and Beyond 49

4. Early 20th Century 69

5. Depression, Recovery, and the Good Old Days 107

6. Vanishing and Lost Yazoo 121

ACKNOWLEDGMENTS

The research and writing of this book would not have been possible without the generous support and help of many individuals and institutions: Ricks Memorial Library, the Yazoo Historical Society, the *Yazoo Herald*, Mary Edwards Brister, Karen Dunaway, Vay Gregory McGraw, Charlie Carlisle, Lena Mae Regan, Louis Williams, Precious Banks, Dawn Rosenberg Davis, Barbara Allen Swayze, Roselynn Soday, Rae Shannon, and Joseph C. Thomas. Those who paved the way for this book through their research, writing, and preservation of local history include Sam B. Olden, Harriet DeCell Kuykendall, JoAnne Prichard Morris, Linda Crawford Culberson, Paul Cartwright, and the Yazoo Chapter of the Mississippi Daughters of the American Revolution.

INTRODUCTION

One might wonder just what "Yazoo" means. It is the name given to a Native American tribe that had more or less disappeared by the time European explorers came to this area. It is the name of a river that courses through the Yazoo-Mississippi Delta, dividing the hills from the vast flatlands stretching for miles. The Yazoo River was to play an important part in the transportation of supplies from the outside world and raw materials to market. Yazoo is the name of the largest county in the state of Mississippi, so big when formed that several counties were eventually carved out of it. And it is the name of a town, once called the "Queen City of the Delta," that has experienced and survived its share of disasters—from tornadoes, floods, and war to a great fire that almost wiped out the town. Nestled on the side of the hills and down to the bank of the river, Yazoo City, which was named Manchester at the time, was the first town in Yazoo County to be incorporated. Being partly in the hills and partly in the alluvial plain known as the Yazoo Delta, Yazoo City has a beautiful setting surrounded by rich farms, fine timberlands, and wonderful fishing streams and lakes. Except in winter, kudzu vine–covered roadsides between Yazoo City and Bentonia add to the unique scenic beauty. From its early days, Yazoo City could be reached by road and river and eventually by rail, and this would have a bearing on the future of the little town and the county. Yazoo's geographic location has been a major factor in its history.

But Yazoo means much more than this. For many years, the region has produced its share of celebrities in the fields of writing, music, and other areas of the arts and entertainment. One person many people associate with Yazoo is Willie Morris. A child of the 1940s, Willie Morris, who went on to fame as the author of *North Toward Home*, *Good Old Boy*, *My Dog Skip*, and other books, always came back to the theme of a sense of place. To anyone from here, no matter how far they go, Yazoo is always home. It is the place in one's mind that is comforting to go back to, whether in books like Morris's or in actuality, and many have come back to Yazoo to live after having been away for years.

Yazoo is such a special place that merely hearing the word spoken makes people feel good, and hearing others mispronounce the word "Yazoo" can bring about a smile. One of the most distinctive things about Yazoo is the name itself. People find it fascinating to say, and it lingers in their memories. Few American cities or counties can claim a name as unique as Yazoo. Romantic legends say that the word "yazoo" means death and that the tribe of Native Americans living here were so brave and fierce and proud they accepted only victory in death. But the truth is that they were a very small and insignificant tribe living at the mouth of the Yazoo River, known for their ability to grow corn. In fact, no one knows for certain what the word meant.

Being proud to call oneself a Yazooan, no matter the place's faults and shortcomings, is what Morris meant by a "sense of place." Morris is quoted in the introduction to *Yazoo: Its Legends and Legacies*, as saying, "And through all this, one loves this place as I have, the perceptions of the venerable continuities of time—the births and deaths, natural and violent, the forgotten

tragedies and triumphs, the sadnesses and joys of man's existence in one small stretch of the planet." Yazoo *is* home.

Being a lifelong Yazooan, I think for these reasons and countless others, a book about Yazoo would be a welcome addition. Photographs for this volume have been collected from families, private collections, the library, local newspapers, and the historical society. More than 200 pictures tell the story of Yazoo from its earliest beginnings through the end of the mid-20th century. This book offers many images of places, personalities, and events of a long-ago but not-forgotten era and is a time capsule of Yazoo's origins.

One

PREHISTORY AND

NATIVE AMERICANS

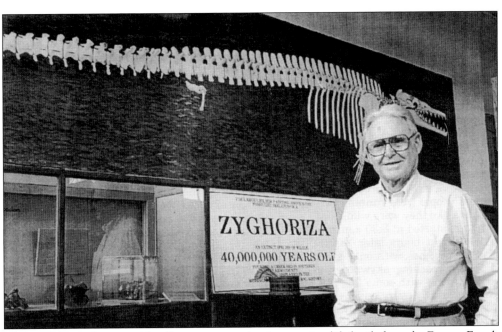

This area was under water 45 million years ago. Ancient marine-life fossils from the Eocene Epoch are found in present-day Yazoo County, including two different ancient whales, *Basilosaurus* and *Zygorhiza kochii*. More like whales today *Zygorhiza* was about 20 feet in length. In this photograph, Sam Olden, longtime president of the Yazoo Historical Society, stands in front of a painting of "Ziggy," the official state fossil of Mississippi, by Julia Deaton. (Courtesy of the *Yazoo Herald*.)

Excavation of *Zygorhiza kochii* by members of the Mississippi Gem and Mineral Society is shown in this photograph. An almost perfect skeleton of *Zygorhiza*, known as Ziggy, was found in Thompson Creek near Tinsley in Yazoo County in 1971 and is now on display in the Mississippi Museum of Natural Science in Jackson. It is probably the most complete of its kind in the world. (Courtesy of the Mississippi Gem and Mineral Society.)

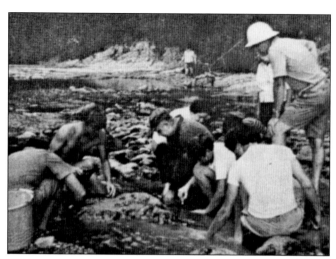

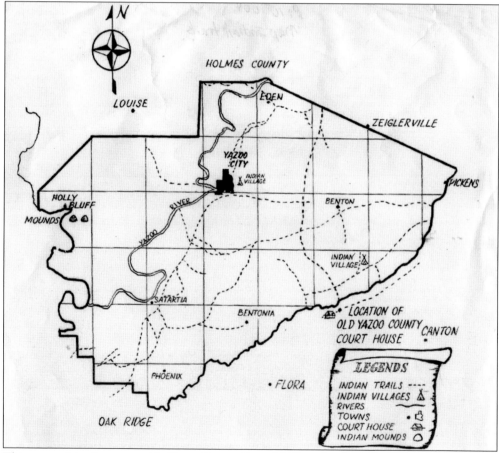

This map originally appeared in *Yazoo County Story* (1958) and was adapted from an 1828 survey by Henry Washington, deputy surveyor for Mississippi and Louisiana at that time. The present county boundaries and town locations have been added to the original designations of Indian trails and villages and the location of the old county seat at Beatty's Bluff. (Courtesy of Ricks Memorial Library.)

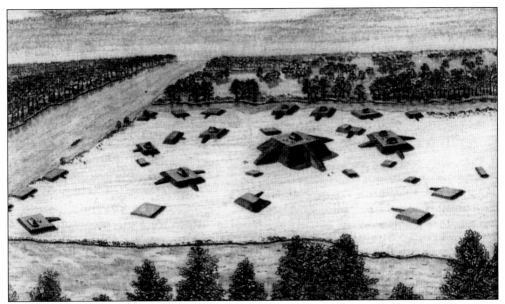

This drawing by Dee Turman shows an archaeological reconstruction of the huge mound complex at Lake George near Holly Bluff, Mississippi, and originally appeared in *The Illustrated Encyclopedia of Native American Mounds & Earthworks* by Gregory L. Little. The village contained 25 mounds and several plaza areas, surrounded by a moat and earthen embankment eight feet high. The largest mound was 60 feet high. (Courtesy of Gregory Little.)

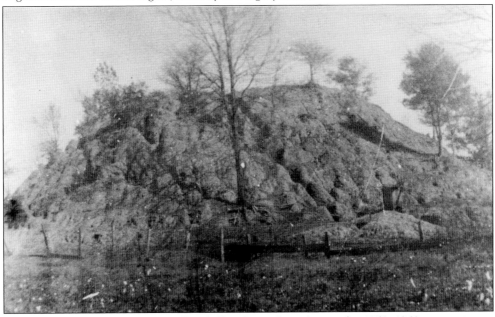

The large Indian mound near Holly Bluff is shown here during the 1958–1960 excavation at the Lake George site by the Peabody Museum. Between AD 700 and 1500, temple mounds were built in Mississippi by early Indians. These impressive mounds were for religious and ceremonial purposes. Beginning around 2000 BC, earlier Indians of the Poverty Point to Baytown cultures were the builders of the small, rounded burial mounds that dot Yazoo County. (Courtesy the Yazoo Historical Society.)

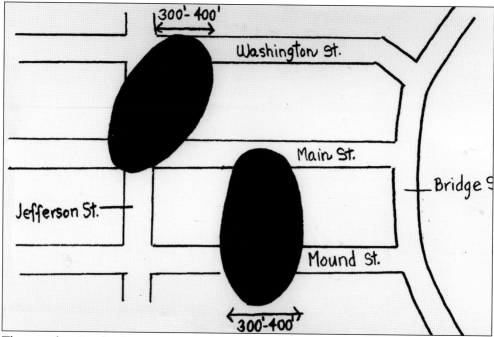

This map, from *Land and Legacy: Yazoo 1823–1973*, shows where two large Indian mounds measuring 300 or 400 feet were located in Yazoo City. These mounds predate the small tribe known as the Yazoo that gave the river, county, and city their names. The Yazoo, numbering fewer than 500 members, had their village near present-day Redwood and spoke their own language, but no one knows for certain what "yazoo" meant. (Courtesy of Ricks Memorial Library.)

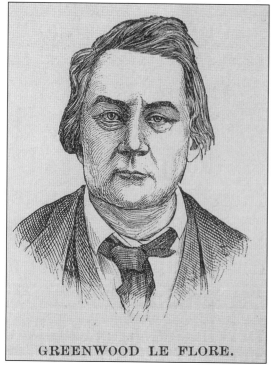

GREENWOOD LE FLORE.

Most of this land was in the possession of the Choctaws, who favored the area for hunting and fishing. Greenwood LeFlore, chief of the Choctaw Nation, after the Treaty of Doak's Stand in 1820, had retained title to land in Mississippi where the Yazoo River curves in to meet the hills. A landing known as Hanan's Bluff was established here possibly as early as 1824. LeFlore sold the land for profit to a group of men who by 1829 had surveyed and platted the area (which was dubbed "Manchester"). Manchester was the first incorporated town in Yazoo County. (Courtesy of Ricks Memorial Library.)

Two

EARLY SETTLERS
AND COMMUNITIES

Yazoo County was created by the Mississippi Legislature in 1823. Beatty's Bluff on the east side of the Big Black River was selected as the first county seat. When Madison County was formed out of Yazoo County in 1828, Beatty's Bluff became part of the new county, and Benton became the second county seat of Yazoo. (Photograph by Pat Flynn, courtesy of the *Yazoo Herald*.)

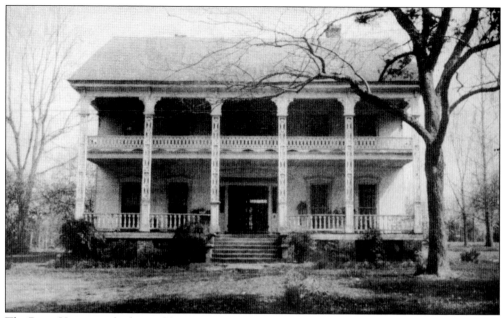

The Berry House was built possibly as early as 1830, soon after Benton became the county seat. One of the unusual features of the house is a hanging, or cantilevered, balcony, built from logs extending the full length of the house and hanging over, not supported by the six pierced and decorated columns. The house was used as a hospital by both sides during the Civil War. (Courtesy of the *Peoples' Press*.)

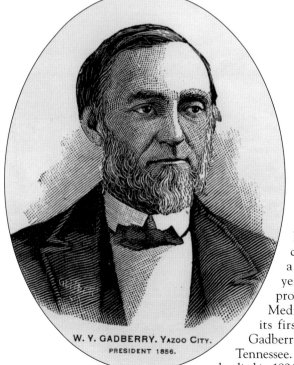

Born in South Carolina, W.Y. Gadberry came to Mississippi and, after becoming a doctor, located in Benton for many years. In 1856, he and other medical professionals organized the Mississippi Medical Association, and he was elected its first president. During the Civil War, Gadberry served as surgeon with the Army of Tennessee. In 1867, he settled in Yazoo City, where he died in 1896. (Courtesy of Ricks Memorial Library.)

Cedar Grove was built in 1834 by John M. Sharp, who came to the Benton area from Tennessee. John Sharp was a captain in the Mexican War. His son, Col. Christopher Harris Williams, was killed at the Battle of Shiloh in the Civil War. Christopher Williams was the father of John Sharp Williams, who became a US congressman and senator. (Courtesy of Ricks Memorial Library.)

Richardson Bowman, an Irish immigrant, came to Yazoo in the late 1820s and built the ancestral home he called Argyle. The original brick house burned, and his son Claiborne Bowman built the house seen here. The first church in Yazoo County was a house also used as a school and was erected by Richardson Bowman on his lands, which contained around 1,000 acres. There was a cemetery near the church, and Bowman had on his farm perhaps the first store in Yazoo County. (Courtesy of Mary Brister Downey.)

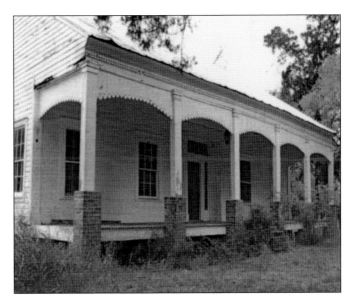

For many generations, the Swayze Home Place located in the Midway community has been farmed by the same family. Richard Swayze received an original land grant in 1832 and built the present home in 1858–1859 with slave labor. In this photograph, the Swayze family is shown in 1954 in front of "Home Place" as it looked before undergoing renovations in more recent years. (Photograph by Stanley Beers, courtesy of Ricks Memorial Library.)

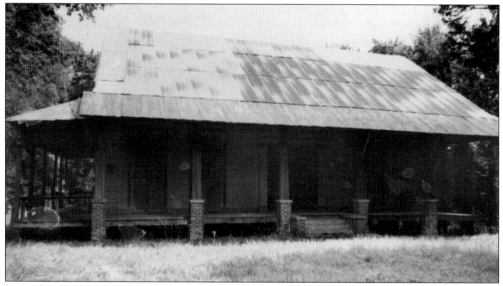

The Penny house, named for its builder and original owner, was constructed before 1860 in Deasonville and was home to generations of the Pepper family. Claude Pepper was a local historian and chronicler of the area's families. The house, built by slaves and put together with wooden pegs, has changed little since it was built. (Courtesy of the Yazoo Historical Society.)

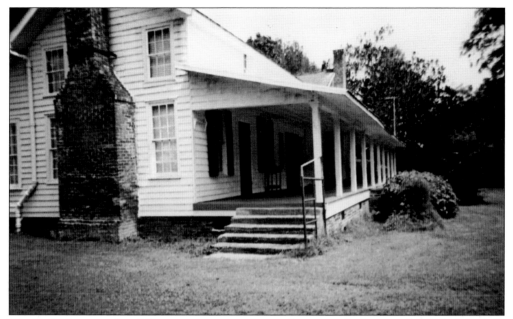

The Bull Homestead and Cemetery consists of an early cottage built around 1835 by J.C. Bull, several adjacent outbuildings and barns, and a family cemetery. It has remained in the same family for five generations. One interesting feature of the house is a so-called "tramp's room," which has only an entrance from the porch and not into the house itself. This room was used by travelers who needed shelter for the night. (Courtesy of the author.)

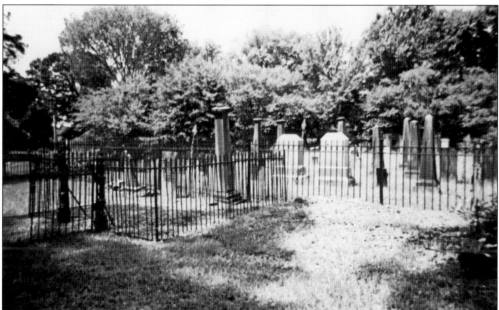

One of the earliest graveyards in eastern Yazoo County is the Bull Cemetery. The first marked grave dates to 1832. Mostly buried here are descendants of James Hogan and Frelove (Lovey) Campbell Bull, but some of those buried are friends rather than relatives. An unidentified Confederate soldier is buried just outside the enclosure, and on the drop of the hill are the graves of slaves and some of their descendants. (Courtesy of the author.)

The Masonic Lodge in Benton was at one time the oldest in the state of Mississippi. Several men are shown here in front of the building, which no longer stands. Benton was a planned town and, after being laid out, was named for Missouri senator Thomas Hart Benton. (Courtesy of the Yazoo Historical Society.)

Mary Belinda (Polly) Luce (1812–1892) married Adamson Waters, who was born in Maryland in 1807 and died in Yazoo County in 1872. They are both buried in the Waters Cemetery in eastern Yazoo County. The Waters family settled early in the Midway community, and Adamson Waters and wife Polly donated in 1857 four acres of land on which the Midway Methodist Church and Cemetery stand. (Courtesy of the author.)

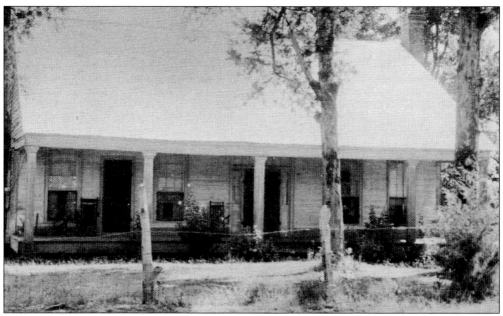

The Big John Hart house was originally located in Harttown. Built by John Hart in about 1843, it represents a typical antebellum planter's cottage. A distinctive feature of the house is its c. 1860 trompe l'oeil decorative paintings, which have been preserved in their entirety. Vacant since the 1970s, the home was purchased by Jep Barbour in 1990, moved 30 miles, and restored. (Courtesy of Ricks Memorial Library.)

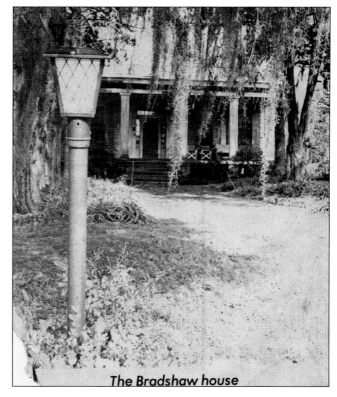

Near Dover, Thomas Edward Bradshaw built the Bradshaw house in 1857. Bradshaw was born in Virginia in 1814 and in 1838 came to Madison County, where he lived for 10 years before coming to Yazoo County. In 1851, he married Margaret Brumfield, with whom he had 12 children. (Courtesy of Ricks Memorial Library.)

The Bradshaw house

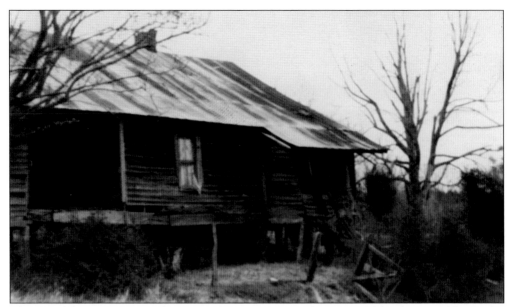

The Perry house, c. 1840s, in the Concord community, was home to Weldon (1881–1955), Martha Rebecca "Miss Mat" Perry (1874–1970), and Tom Perry (1886–1974). This was an open dogtrot house with a porch extending across the front (shown here in the mid-1970s is the rear of the house with a small lean-to kitchen porch). After being vacant for years and used to store hay, the house burned in the 1980s. (Courtesy of the author.)

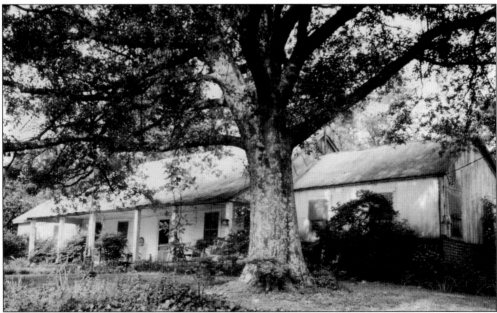

The old White place, built about 1840, was home to Charles Henry "Charlie" White (1859–1943), who sold the house to the current owners in the 1930s. Said to be 100 years old at the time, the house was originally a one-room log cabin, and later, a dogtrot. Legend has it that the young girl who lived here had a pet deer in the yard. One day, the deer attacked the girl and killed her. Weldon Perry, her boyfriend from just down the road, was so brokenhearted that he never married. (Courtesy of the author.)

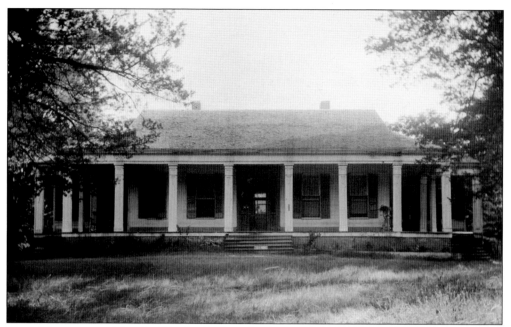

Bleak House, named for the Charles Dickens book, was an expansive, single-story house built with slave labor on the old Benton Road just east of Yazoo City in 1850 by Judge S.S. Wright. Three years later, it was purchased by N.G. Nye. A gallery supported by a dozen square columns ran 120 feet across the entire front and side. During the Civil War, soldiers fought from the public road and on the lawn of Bleak House. In 1940, during the ownership of Dr. J.T. Rainer and Mrs. Louise Reid Rainer, the house was destroyed by fire. (Photograph by James Butters, courtesy of the Library of Congress, Historic American Buildings Survey.)

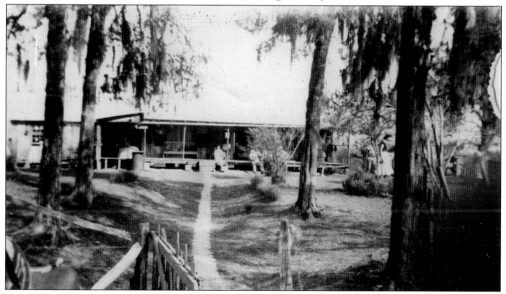

The old Logan dogtrot house, located near Liverpool Baptist Church, was home to generations of the Logan family. Dogtrot houses had an open passageway through them, and it was said a dog could trot through this hall. This picture dates from after World War II. (Courtesy of Rae Shannon.)

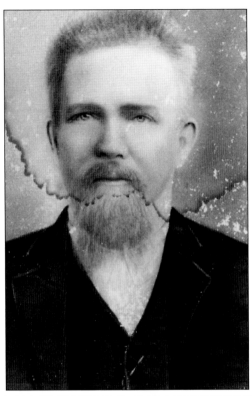

Pinkney Sumrall Logan (1840–1905) was born in Alabama and died in Yazoo County. He came to the area prior to 1860 and married Sally Edmonds (1836–1921). They had seven sons and one daughter. Squire Logan, a justice of the peace for a number of years, and Sally Logan are both buried in Liverpool Baptist Church Cemetery. (Courtesy of Rae Shannon.)

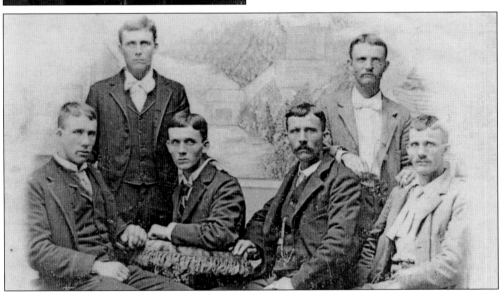

Six of the sons of P.S. and Sally Logan are pictured here in the early 1900s. From left to right are Joseph Johnson "Joe" Logan, Brackston Smith Logan, George Tuttle Logan, Willis Logan, Ethel Lytton Logan, and Eddie Emory "Ned" Logan. Joe Logan, the youngest (born in 1880), was driving a team of oxen pulling a log wagon near Valley when he was pulled beneath the wheels and crushed to death. Joe Logan was married to Ella Ellzey, and they had eight sons—McKinley, Coke, Homsey, Alvin, Benny, Julius, and Malcolm—and one daughter, Hazel. (Courtesy of Rae Shannon.)

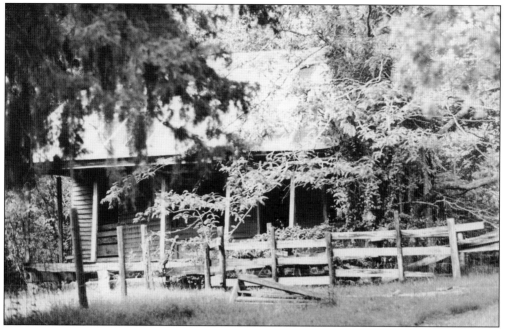

The I.H. Perry house, dating from the 19th century on Perry Creek Road, was a 1.5-story log structure built in the hills between Oil City and Satartia. With a full front porch, the house was a double pen with a center hall and a staircase to the upper floor. There were enormous chimneys on both sides of the house. (Courtesy of the Yazoo Historical Society.)

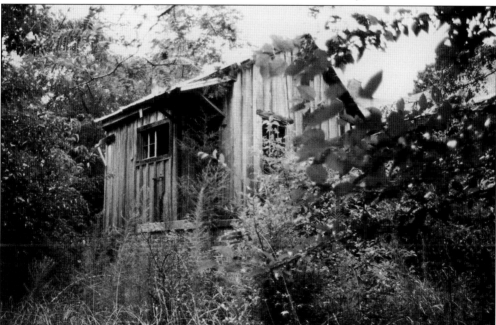

The detached kitchen just behind the Perry house on Perry Creek Road is shown in another photograph from 1975. A large cistern was nearby for holding water. Kitchens were built separate from the main house to protect from fires starting there and spreading to the rest of the home. (Courtesy of the Yazoo Historical Society.)

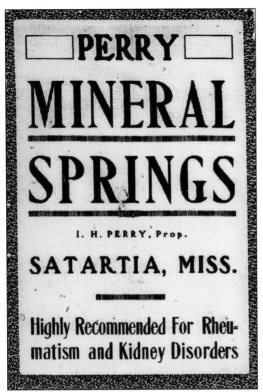

I.H. Perry was the proprietor of Perry Mineral Springs and sold mineral water from the springs located behind the Perry house. This old poster advertised his mineral water as highly recommended for rheumatism and kidney disorders. The house and kitchen were torn down in the late 1980s, as was an unusual structure behind the house that had an overhanging roof on all sides, similar to outbuildings that might be found in Louisiana. (Courtesy of the author.)

The Hamberlin-Kinard-Jones log house, located near Tinsley and originally consisting of two large rooms constructed of logs hewn to fit without nails and a center hall (or dogtrot), was built prior to the Civil War by William Anthony Hamberlin and his father, Samuel F. Hamberlin. It was not completed until after the war by Laura Hamberlin Kinard and her mother, Jane Delilah Roose Hamberlin, the wife of William Anthony Hamberlin. Laura Kinard's daughter Maggie married D.E. Jones, and the house has remained in the Jones family since. (Courtesy of Teresa Ann Jones.)

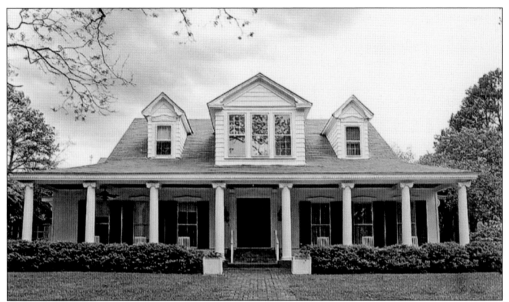

No Mistake Plantation, originally a 10,000-acre cotton plantation near Satartia, was established in 1833 by James and Nathaniel Dick, wealthy New Orleans merchants. James Dick wrote his brother Nathaniel about the land, and Nathaniel advised that "we would make no mistake buying [it]." This house was originally the overseer's home. Francis Pleasant Smith purchased the property from the earlier owners in 1888, and later, under the ownership of Ethel Barfield Smith, this farm became known for its beautiful gardens. (Courtesy of Dawn Rosenberg Davis.)

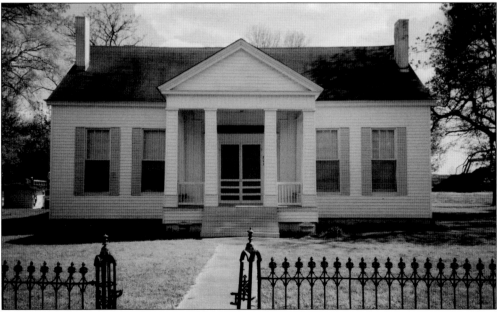

Robert Wilson built Kling House at Satartia with slave labor in about 1848. During the Civil War, Union soldiers occupied the house. Written on the rooms' walls are these words, "To the unknown owner of this house, your case is a hard one and I pity you though I cannot relieve" and "How are you Rebel?" Soon after the war, New York native Monroe Kling came to Satartia and married Elizabeth Wilson, only child of Robert Wilson. (Courtesy of the author.)

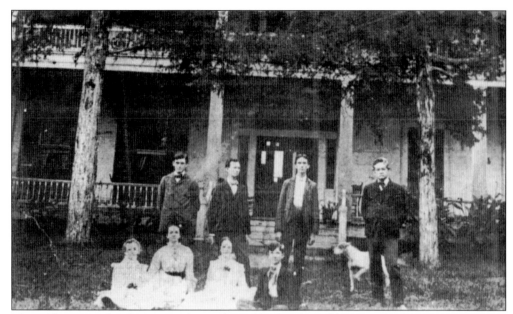

This old, c. 1890 family picture shows the Gibbs family and heirs at the house at Woodbine Plantation when it still had the original second-floor gallery. This gallery was later removed and replaced by a small balcony. During a recent restoration, the gallery was rebuilt. (Courtesy of the *Yazoo Herald*.)

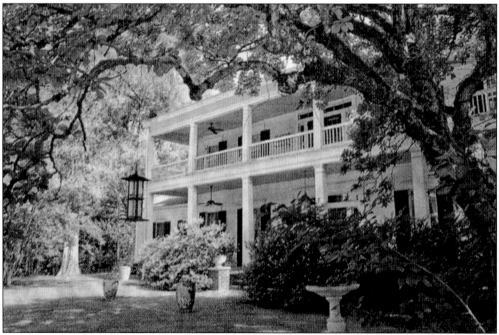

Dating from 1841, Woodbine was built using slave labor by John and Louraine Johnson and was named for the profusion of Virginia creeper that grows in the surrounding woods. Set far back on a rise in a beautiful woodland, this impressive home was recently restored to its original splendor. Woodbine was home to famed bluesman Nehemiah "Skip" James in the early 20th century. (Courtesy of Dawn Rosenberg Davis.)

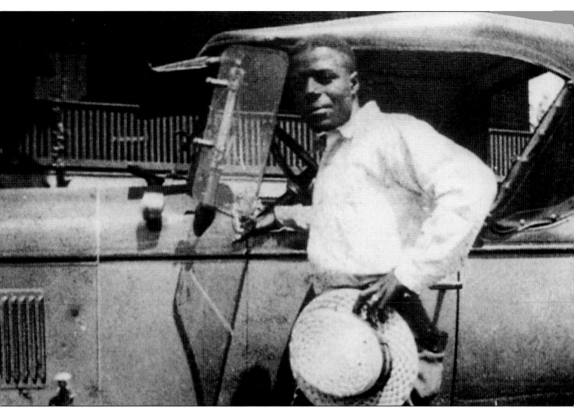

Skip James was born in 1902 and lived at Woodbine Plantation, where his mother was a cook. He grew up in Bentonia and learned the Bentonia blues from Henry Stuckey, another early bluesman from the area. For a while in the 1920s, James was the bootlegger for the plantation. Renowned for his fingerpicking, he became a world-famous master blues guitarist and toured worldwide. His astonishing performances were first recorded in 1931. James is known for songs such as "Hard Time Killing Floor Blues," "Devil Got My Woman," and "I'm So Glad." Said to be too much of an individual and too much of a genius to be copied, he made a short comeback in the 1960s before dying in 1969. Skip James is shown here in what is believed to be the earliest known photograph of him, taken sometime in the 1920s.

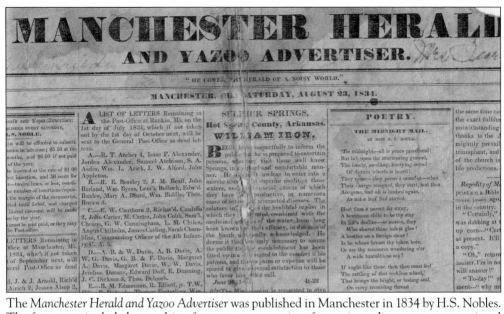

The *Manchester Herald and Yazoo Advertiser* was published in Manchester in 1834 by H.S. Nobles. The front page included everything from poetry to copies of new city ordinances to promotional articles. The only known existing copy of this paper (Vol. 1, No. 25, August 23, 1834) was donated to Ricks Memorial Library by longtime city clerk Harrell Granberry, who found it lining a dresser drawer. (Courtesy of Ricks Memorial Library.)

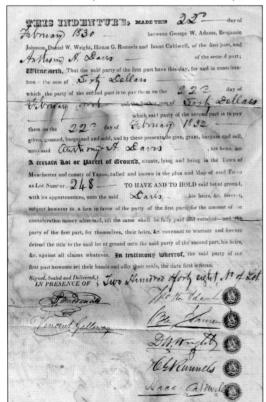

This deed shows that on February 22, 1830, Anthony H. Davis purchased lot No. 248 in the town of Manchester, Mississippi, for the sum of $120. The sellers were George W. Adams, Benjamin Johnson, Daniel W. Wright, Hiram G. Runnels, and Isaac Caldwell, entrepreneurs and partners in the venture establishing Manchester. Hiram G. Runnels was elected governor of Mississippi in 1833. (Courtesy of Ricks Memorial Library.)

The Hollies home dates back to the days when Yazoo City was named Manchester. The house was built of sturdy cypress, wooden pegs, and square nails. Records show that the land on which it was built was divided into lots in 1830. Dr. Washington Dorsey bought a lot in 1834 and built the house that now stands, making its construction date one of the earliest in Yazoo City. (Courtesy of the *Yazoo Herald*.)

Another of the oldest houses in town is the Dalton house on North Monroe Street, which has been much altered from its original form. This house is recorded as having been sold with the property in 1837. The inset porch probably had rectangular box columns, which were at some time replaced by the present turned-Victorian posts. (Courtesy of Roselynn Soday.)

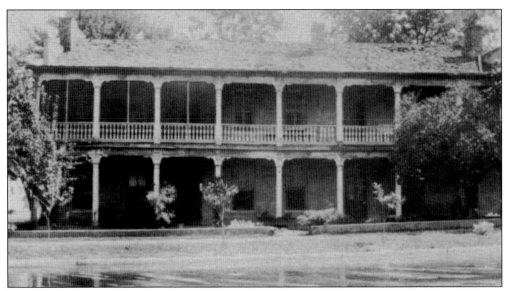

The c. 1829 building known as Polly Miller's Tavern, and later as the Stubblefield house, was torn down many years ago, but at the time it was probably the oldest home in Yazoo City. In the early years, it was one of the two hotels available. The house changed hands and became known as the Stubblefield house when Sheriff William Henry Stubblefield purchased it from the Henley family in about 1881. (Courtesy of the Ricks Memorial Library.)

The history of the library in Yazoo County began with the creation of the Manchester Library Association on September 8, 1838. When Manchester changed its name to Yazoo City in 1839, the library followed suit and became the Yazoo Library Association, the second oldest such association in the state (Port Gibson was first). Pictured here is the first page of the original minute book. (Courtesy of Ricks Memorial Library.)

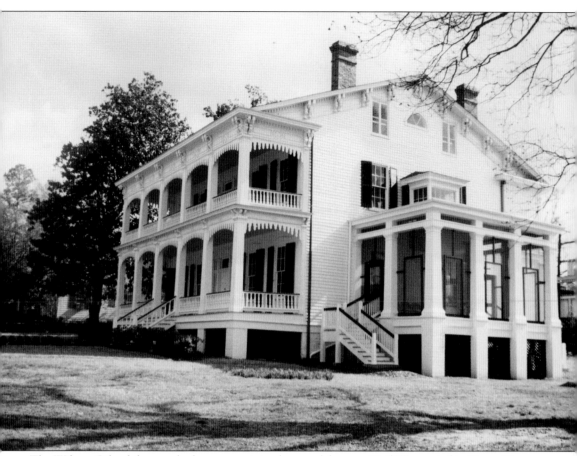

The Wilson-Gilruth house, the largest surviving house of the pre–Civil War period in Yazoo City, was built by Samuel H. Wilson for his bride, probably in 1846. The front of the house comprises two levels of porches with rectangular section columns and turned balustrades. The original Greek Revival character is somewhat masked by decorative wooden icicles inserted between the columns around 1881. It is believed that the house was precut and shipped downriver from Cincinnati, Ohio. After the Civil War, the house was acquired by Col. I.N. Gilruth, and it is still owned by Gilruth descendants. (Courtesy of Ricks Memorial Library.)

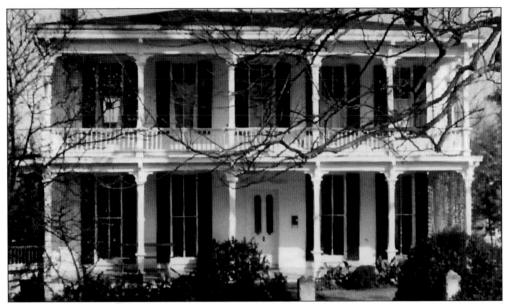

Historically known as the Wilson-Tyler house and one of the oldest in Yazoo City, this house has a bottom floor with brick walls dating from the earliest construction. Dr. James Wilson built the house possibly as early as 1840. Rev. Richard McInnes, founder of the First Presbyterian Church, bought the cottage in 1844. Before the Civil War, Henry Clay Tyler and his wife, Cornelia Cusack Tyler, purchased the house and added the second floor. Tyler later remodeled the house, adding the kitchen and Italianate galleries in the 1870s. Tyler, a jeweler, gave the clock for the courthouse to the town. (Courtesy of Roselynn Soday.)

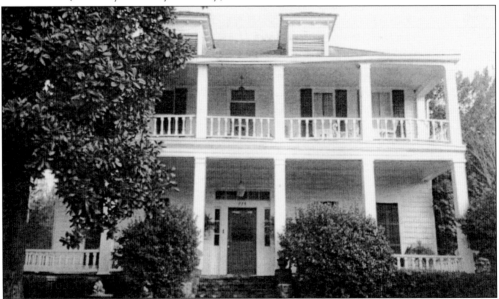

Bardwell sits on a lot that was part of the original plat of Manchester. The first deed was recorded in 1830 by grantors Polly W. Johnson and Hiram G. Runnells, governor of Mississippi from 1833 to 1835. In 1853, the lot was sold, and there are indications that a house was there by that time. The property was purchased in 1890 by James A. Bardwell, who added the second floor after 1905. Shading the front galleries is probably the largest magnolia tree in Yazoo City. (Courtesy of the author.)

Judge Robert Bowman, a prolific local historian of the last half of the 19th century, was associate editor of the *Yazoo Democrat* and later practiced law. Elected probate judge in 1859, he entered military service in the Confederate army as a captain in 1862. After the war, he returned to Yazoo City and resumed his law practice. Judge Bowman was the author of *Early History and Archaeology of Yazoo County*, *Yazoo County in the Civil War*, and *Reconstruction in Yazoo County*. (Courtesy of Ricks Memorial Library.)

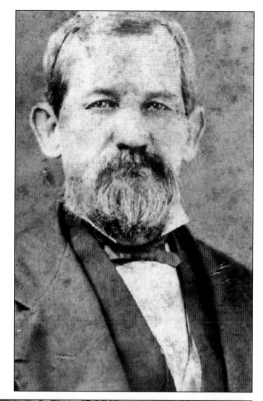

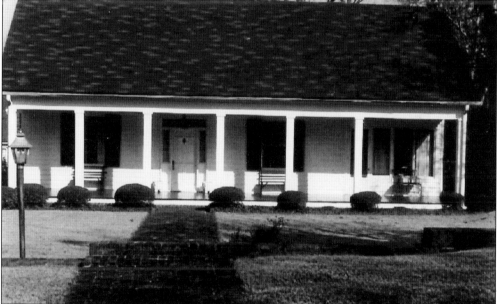

Originally owned by the Lamkin family, the Judge Bowman place was built in 1852. Judge Robert Bowman purchased the house in 1867 and later sold it to Judge Edwin Holmes, and afterwards, the house belonged to attorney John Sharp Holmes. Two rooms across the front and the inset porch with square boxed columns are part of the original house; the back was rebuilt. (Courtesy of Roselynn Soday.)

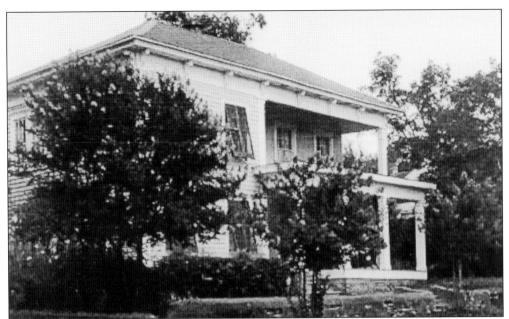

The Twellmeyer house was built by Henry Twellmeyer in 1857. Henry and Elizabeth Twellmeyer's son Francis Xavier Twellmeyer, who was born in Yazoo City in 1866, has the distinction of being the first Catholic priest ordained from the county. Father Twellmeyer attended St. Clara Academy just across the street from his home on North Monroe Street. In 1924, he was named president of Loyola University in New Orleans. (Courtesy of the author.)

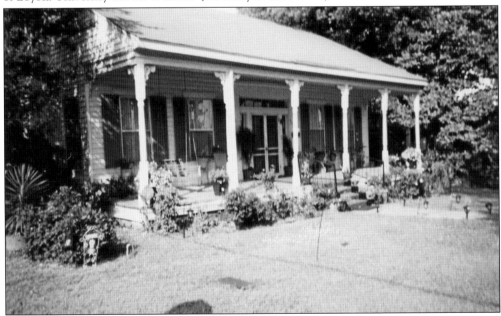

Cadenhead house, at the corner of Madison and Monroe Streets, is a Greek Revival cottage, dating from around 1850. The front entrance is characterized by a low pediment with dental molding original to the structure, although the French doors are modern replacements. It follows the antebellum farm-dwelling style with later additions, including the turned Victorian columns. (Courtesy of the author.)

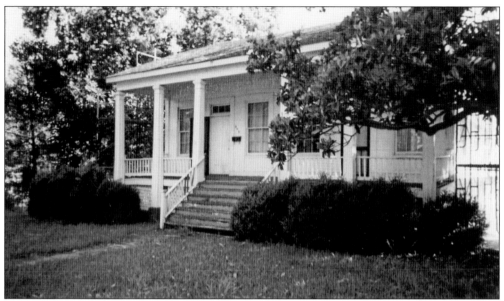

The Pugh-Blundell house is a Greek Revival raised cottage built by Col. William E. Pugh shortly after the property was acquired in 1849. An inset porch extends across the front, with a full basement at the ground level. From the porch, two doors lead into each of the front rooms. Inside, monumental, two-panel Greek Revival doors open directly into double parlors. During the Civil War, a cannonball passed through the house and landed in a downstairs room without exploding. (Courtesy of the author.)

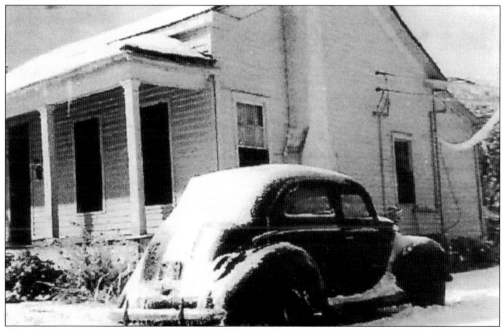

This pre–Civil War house is an example of the small, vernacular, Greek Revival cottages found in early Yazoo City. It was built on property purchased in 1859, and some say it was originally a carriage house for the Wilson-Tyler house just behind it. The house has undergone some changes but retains much of its original fabric. (Courtesy of Mary Brister.)

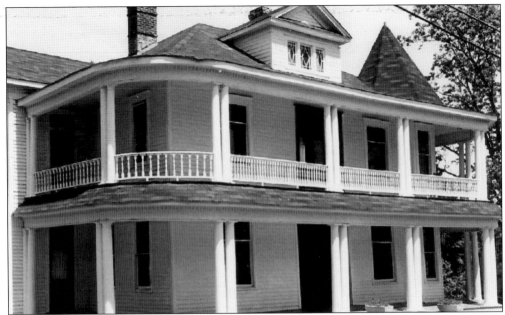

The Oakes house was built in stages between 1866 and 1910 by John and Mary Oakes, free blacks who had moved to Yazoo City by the late 1850s, and by their first son, Augustus J. Oakes, an educator and builder born in 1854. Following the Great Fire of 1904—in which most of downtown Yazoo City was destroyed—Oakes, whose lumberyard did not burn, was able to supply much of the material for rebuilding the town. (Courtesy of Karen Dunaway.)

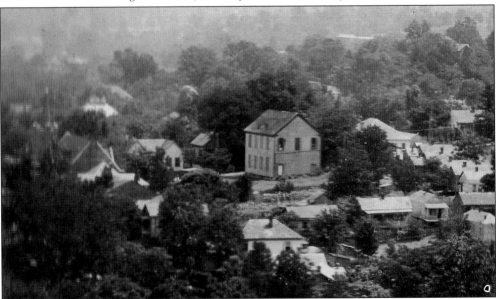

Oakes Academy, seen here from the rear, was located on Jefferson Street near where St. Stephens United Methodist Church stands today and was the first high school for blacks in Yazoo City. It was opened in 1884 by Augustus J. Oakes Sr., who was a teacher and principal in schools throughout Mississippi. In 1900, Oakes resigned his career as an educator to become more active in his family's businesses, which included a lumberyard, a coal company, and a construction company. (Courtesy of the Yazoo Historical Society.)

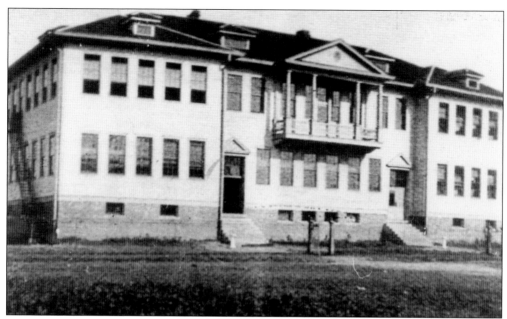

The old Public School No. 2 was located on Lamar Avenue. Prior to 1907, Yazoo City had no decent school building for African Americans. The school board floated bonds in the amount of $70,000, and A.J. Oakes Sr. supported education by buying all the bonds. Oakes also supplied labor and materials for building the school, which remained the public school for blacks until the early 1950s. (Courtesy of Precious Banks.)

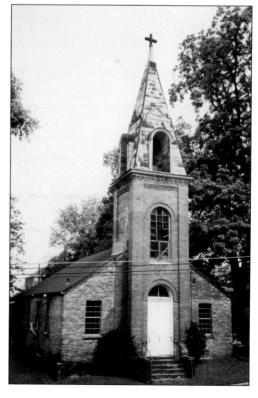

Bethel AME Church was organized in 1868 and is the oldest African American congregation in Yazoo City, having occupied this site since 1890. Bethel is one of the earliest brick churches built by African Americans in Mississippi, and it is the oldest church building still standing in Yazoo City, having survived the Great Fire of 1904. Although there have been alterations, Bethel retains its historic Romanesque Revival bell tower. (Courtesy of the author.)

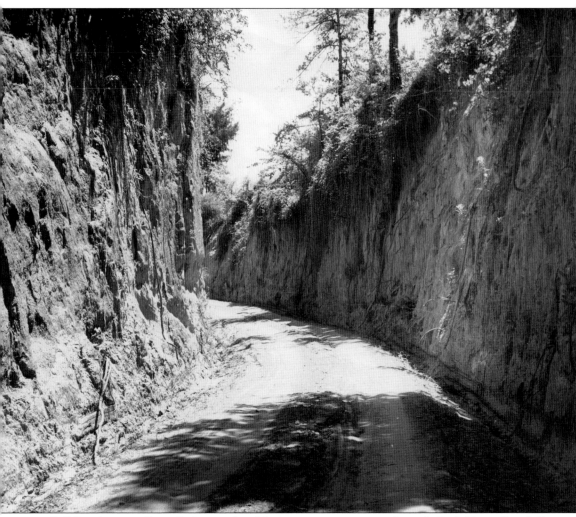

Bell Road, originally an Indian trail and later a wagon route, cut through Peak Teneriffe, a hill south of town. Bells were at each end of this one-way, twisting cut through the hill. When wagons traveling in opposite directions arrived, the first one to ring the bell was supposed to have the right-of-way. The old road followed the top of the bluffs overlooking the rich Yazoo Delta country. Another early public road that had been an Indian trail extended eastward from present-day Yazoo City. Later, this trail was cut wider to allow for the transportation of cotton from counties east of Yazoo to be shipped to markets. About 1848, a new "highway" was built from Yazoo City to Benton, partly consisting of a plank surface. This old plank road proved unsatisfactory by 1850. (Courtesy of Ricks Memorial Library.)

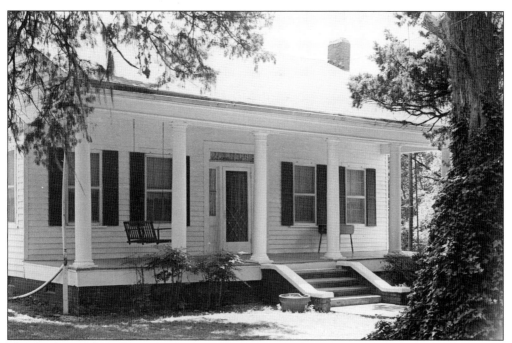

The Starling-Wilburn house, located on old Bell Road, is historically known as the Mosely-Woods House and was built around 1860. William Mosely, an early black landowner, purchased the house and land in 1880 from Ann Holt and bought additional acres from her in 1884. After his death, Mosely's heirs sold the property to one of his grandchildren, Mary Woods, in 1909. This is one of the oldest African American residences continuously owned by the same family in the Yazoo area. (Courtesy of Karen Dunaway.)

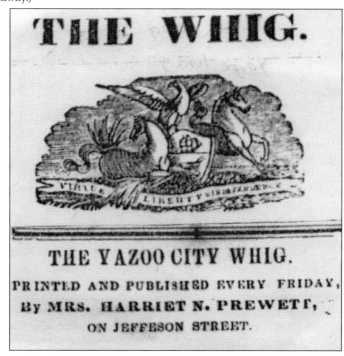

The *Yazoo Weekly Whig* newspaper was distinct because its editor was a woman. Harriet N. Prewett in 1850 became the first female newspaper editor in Mississippi. She was the owner and editor of the *Yazoo Weekly Whig*, and after 1855, the *Weekly American Banner*. In the 1840s, Yazoo County voted Whig, but by the early 1850s, the Whig Party in Mississippi had virtually disappeared. (Courtesy of Ricks Memorial Library.)

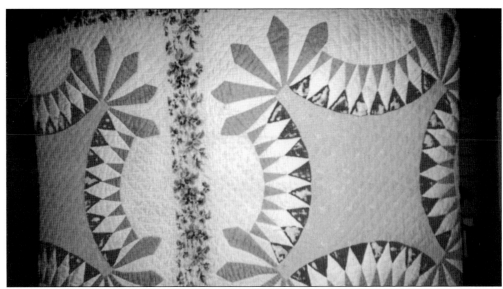

Quilts are sometimes the only record that survives of women's creativity, personality, and thought. Quilters often discussed politics even if they could not vote, and this showed in the names of quilt patterns, such as this example of "Whig's Defeat," an old pattern popular in the 1850s. Sarah Greenwood made the quilt when she married Columbus C. Luckett in 1857. Sarah was the great-grandmother of Tootie Sutherland Weisenberger, whose family donated the quilt to the local museum. (Courtesy of the Yazoo Historical Society.)

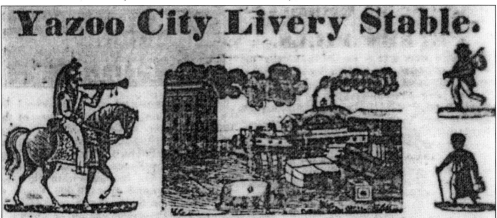

This advertisement, which appeared in the August 28, 1846, *Yazoo City Whig*, promoted the sale of "horses, mules, Negroes, and other property" on commission at the Yazoo City Livery Stable. When the Whigs withered as a national party and were replaced by the Know-Nothing party, many Mississippians embraced the new organization, as did Harriet Prewett. She changed the name of her newspaper to the *Weekly American Banner*. (Courtesy of Ricks Memorial Library.)

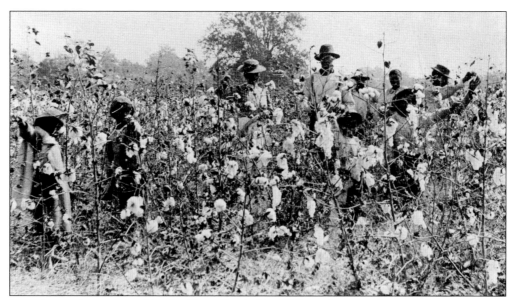

In a picture that appeared in the *Yazoo Sentinel* in 1902, workers are shown picking cotton on one of J.R. Lacey's plantations. Cotton was greatly responsible for the growth of Yazoo City as all the cotton marketed from the counties east and northeast had to come to Yazoo City to be loaded on boats for New Orleans. (Courtesy of Ricks Memorial Library.)

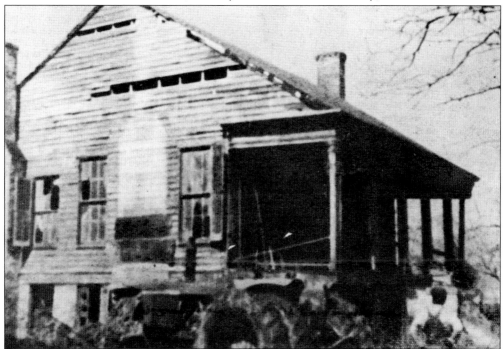

Koalunsa, a plantation house on Carter Road built in 1853 by M.R. Payne, is shown in this 1970 photograph before restoration. The main house was four large rooms with a wide center hall. Beneath this floor was a large brick basement with a wine cellar, kitchen, and dairy. The basement had plastered walls, brick floors, fireplaces, and iron-barred windows. Some say slaves were kept here when they were brought up the river for resale. (Courtesy of the *Yazoo Herald*.)

Koalunsa was restored in 1975. There were originally two small cottages on either side of the main house, but they are no longer standing. These side cottages had two large rooms, dressing rooms, and furnished attic rooms reached by hidden stairs. One of the cottages was moved to Rialto Plantation after the house there burned. (Courtesy of the *Yazoo Herald*.)

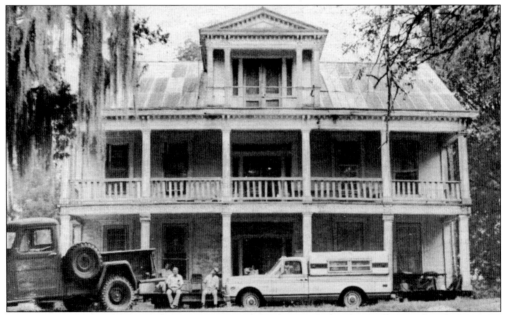

One of the grandest homes in Yazoo County was built in 1859 by the Holloman family. Because of its remote location—about six miles from Phoenix on the Vicksburg Road—the house escaped the ravages of the Civil War and Reconstruction. It did, however, serve to quarter soldiers during the war. Time, neglect, and finally a fire brought the end to Holloman house. (Courtesy of the *Peoples' Press*.)

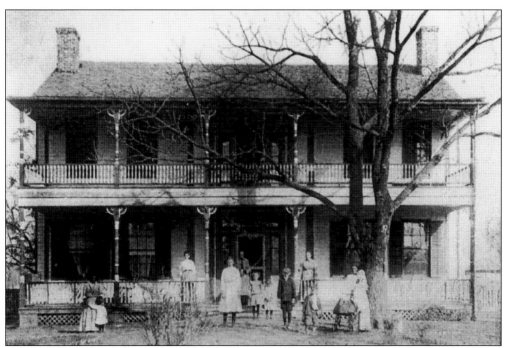

The Belle Prairie plantation home was built in 1828 by Maj. William Phillips on a 3,000-acre plantation on the Yazoo River north of Yazoo City. This fine old house stood until 1950 when it was destroyed by fire. Shown in this early photograph is a later generation of the Phillips family. Belle Prairie was purchased by Benjamin S. Ricks Jr. from Phillips, and it was later purchased from the Ricks family by Major Phillips's grandsons. (Courtesy of KK Hill.)

Linden was constructed before the Civil War, on the west bank of the Yazoo River, and was purchased by E.T. Clark. Built by slaves from trees that grew on the plantation, Linden gained fame in the 1970s in Willie Morris's book *Good Old Boy* as the haunted old Clark mansion. Yazoo historian Sam B. Olden was born at nearby Coon Camp, another Clark property, in 1919. While Linden is no longer standing, its large plantation bell now hangs in the local museum named in honor of Sam B. Olden. (Courtesy of Ricks Memorial Library.)

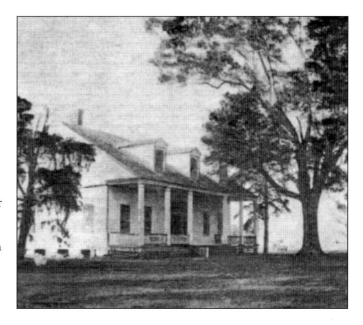

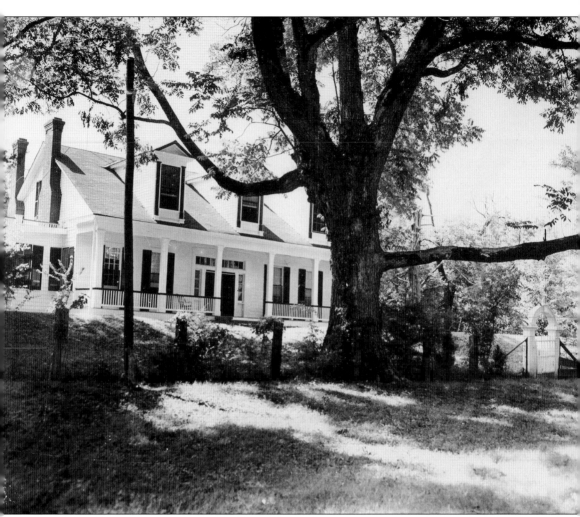

Kinkead, or P-Line House, was built in 1849 by architect James Gwaltney and is a Greek Revival farmhouse that has been in the Kinkead/Dent family for seven generations. It served as headquarters for the Parisot steamboat line owned by Sherman Parisot and James Dent. The P-Line House is a true four-room, center-hall home, which faces the east bank of the Yazoo River. A full front gallery is supported by six square columns. Originally a full two-story building, its top was wrecked by a storm, and it was rebuilt with three dormer windows as it is today. (Photograph by Stanley Beers, courtesy of Ricks Memorial Library.)

Sherwood, built around 1840 by Capt. John J. Jackson on Monroe Street in Yazoo City, was held together with pegs and mortised joints. Col. I.N. Gilruth bought the house and moved it to Lake City around 1900. Completely dismantled, put on a shallow steamboat at the landing in Yazoo City, and carried from there to Broad Lake and then into Wolf Lake, the house was needed for Colonel Gilruth's land manager in the area. Lake City was, at that time, a thriving community because of its steamboat landing. (Courtesy of the author.)

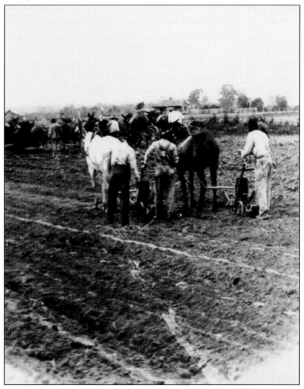

Shown in this early picture are farmhands plowing the field with mules. By 1900, there were some 12,000 horses and mules in Yazoo County as farm power was almost an exclusively horse-and-mule–type operation. By 1955, this number had dropped to around 5,000 as tractors became more prevalent. An old farmhouse and a barn are visible in the background. (Courtesy of Ricks Memorial Library.)

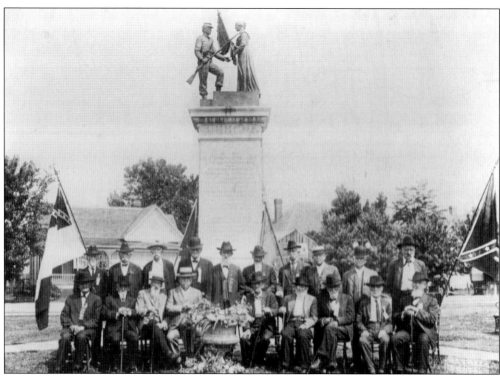

After serving in the Civil War, Col. Emile Schaefer (first row, just right of center in this 1909 photograph of Confederate veterans) came to Yazoo City, became active in commercial circles, and later began planting. He owned large acreage, including Inchuka and Tokeba plantations, producing cotton. Inchuka later became known as a dairy farm. Schaefer was a member of the city council, served on the board of supervisors, and served on the city school board as president. After the death of his first wife, Caroline Weinschenk, he married a second time to Julia Marx. Schaefer died in 1918. (Courtesy of Ricks Memorial Library.)

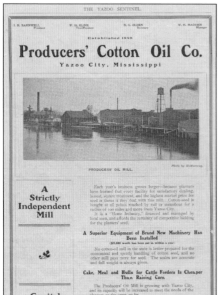

The Producers' Cotton Oil Co. was established in 1898 with Benjamin Ricks as president. Ricks was on the levee commission and also had shares in the compress as well as his land holdings, some 18,000 acres after the Civil War. In 1860, prior to the war, he had 139 slaves to work the land (Courtesy of Ricks Memorial Library.)

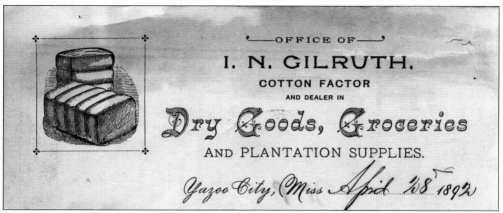

This letterhead for the I.N. Gilruth Company is dated 1892. Gilruth was a cotton factory and dealer in dry goods, groceries, and plantation supplies. His company owned and operated the following 14 Delta plantations: Wilton, Steward Ridge, Eagle Bend, Lake Dick, Rose Hill, Sherwood, New Era, Ivanhoe, Deerfield, Myers, Bright Bank, the New Place, Humphrey, and Blanchard. Gilruth's warehouse, located on South Main Street, was one of the few buildings to survive the Great Fire of 1904. (Courtesy of Ricks Memorial Library.)

The Gilruth Company warehouse, pictured as it appeared in 1902, supplied not only its own plantations but was also a general-supply business as well. Col. I.N. Gilruth, an officer in the Federal army, came to Yazoo County after the Civil War and invested his capital in what formed the nucleus of the interests owned by the Gilruth Company. At the time of his death in 1899, the business had assumed vast proportions. This building collapsed in 2012 and was removed. (Courtesy of Ricks Memorial Library.)

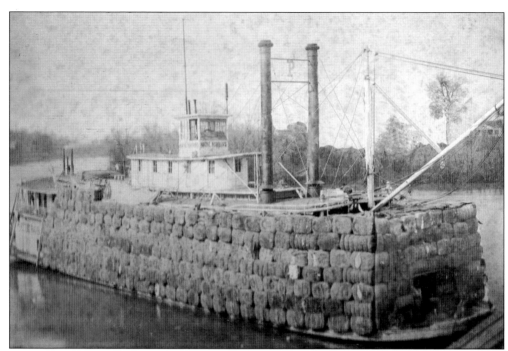

The P-Line steamboat *Katie Robbins*, built in 1884, is shown loaded with cotton. In January 1890, the *Katie Robbins* sank near the mouth of Deer Creek. In the far right background of the picture is a house called Point Industry, which was owned in the 1840s and 1850s by John I. Wilson. Wilson was a wealthy man and owned many slaves. During a yellow fever epidemic in 1853, Wilson remained and nursed his sick slaves, all of whom survived, but he caught the malady himself and died, as had his wife earlier. (Photograph by Patorno & Coovert, courtesy of Marsha Dunn Williams.)

Point Industry, pictured near the center of the image in 1915, was a one-story Greek Revival cottage built on the west bank of what is now Lake Yazoo. Considering the ravages of time and the overflows of the river in 1882 and 1927, when water reached several feet into the house, it is amazing that it is still standing. Although it has been moved and is in disrepair, the original front doorway is intact. During the Civil War, soldiers were quartered here, and it was at one time used as a hospital for the wounded. (Courtesy the Yazoo Historical Society.)

Three

CIVIL WAR, RECONSTRUCTION, AND BEYOND

At the beginning of the Civil War, Yazoo City and the Yazoo River would have appeared much as they do in this early photograph. The Confederate Navy Yard was just south of town, and Union boats would have come up the river from Vicksburg and around the bend in the river. The USS *Baron DeKalb* was sunk just south of here in 1863, and the Union tin-clad *Petrel* was captured above Yazoo City in 1864. (Courtesy of the Yazoo Historical Society.)

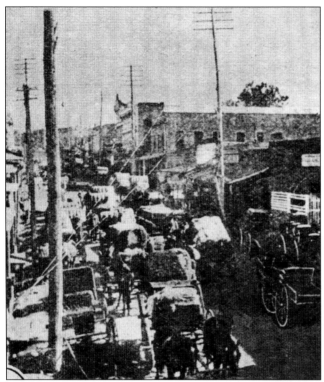

The lower end of Main Street is crowded in this early scene photographed a few years after the Civil War. The two-story building near the center of the picture was used as the makeshift Confederate hospital. It survived the Great Fire of 1904, but the rear wall collapsed in the late 1980s, causing one of the oldest buildings in the business district to be demolished. (Courtesy of Ricks Memorial Library.)

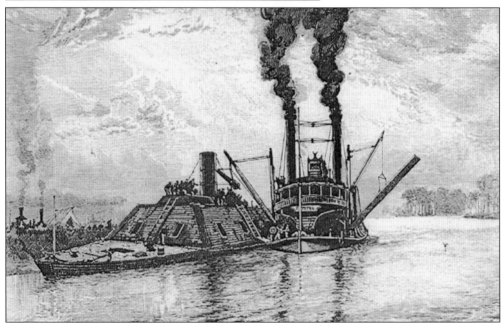

A drawing by J.O. Davidson shows the building of the CSS *Arkansas* at the Confederate Navy Yard in Yazoo City. The navy yard contained five saw and planing mills, a machine shop, and carpenter and blacksmith shops. The ironclad Confederate ram CSS *Arkansas* was completed here and launched on July 14, 1862, commanded by Lt. Isaac N. Brown. (Courtesy of the Naval History & Heritage Command.)

Lt. Charles "Savvy" Read, Confederate States Navy (CSN), earned the nickname "Seawolf of the Confederacy" for his exploits and daring. Born in Yazoo County in 1840, Read, at the outbreak of the Civil War, resigned his commission with the US Navy and accepted a position with the CSN. Read served as an officer on the CSS *Arkansas* during its actions near Vicksburg and during its final battle supporting the Confederate army assaulting Baton Rouge, Louisiana, on August 6, 1862. (Courtesy the Yazoo Historical Society.)

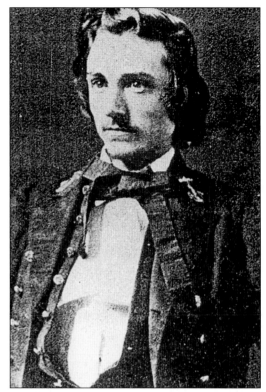

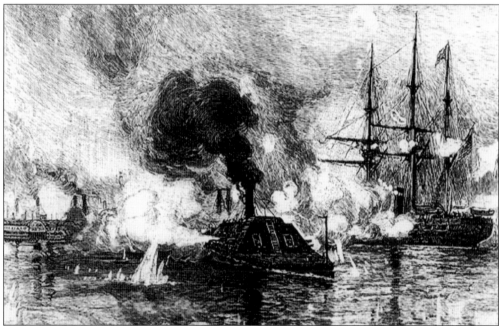

This battle scene shows the Confederate ram *Arkansas* running through the Union Fleet of 39 vessels on July 15, 1862, at Vicksburg, Mississippi. The "bucket of bolts" had almost single-handedly lifted the siege of Vicksburg. In his report, Adm. David Farragut expressed "deep mortification" that the *Arkansas* had escaped. (Courtesy of the Naval History & Heritage Command.)

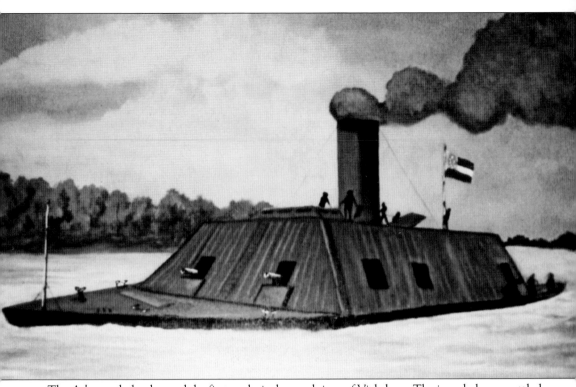

The *Arkansas* helped to end the first exclusively naval siege of Vicksburg. The ironclad was scuttled north of Baton Rouge on August 5, 1862, to prevent capture by Union forces. Admiral Farragut wrote Washington and exclaimed, "This is the happiest day of my life!" The Confederate Navy Yard at Yazoo City was burned by direction of Lt. Isaac Brown, CSN. It was occupied on May 21, 1863, by Federal forces, which also seized the vessels *Mobile* and *Republic*. The Arkansas was an ill-fated ship from the beginning, but its success for a few weeks electrified Southerners with hopes of victory and terrified Northerners. The 24-day rampage of the *Arkansas* secured the Yazoo City naval yard a permanent place in naval history. (Painting by Bob Coleman, courtesy of Yazoo Historical Society.)

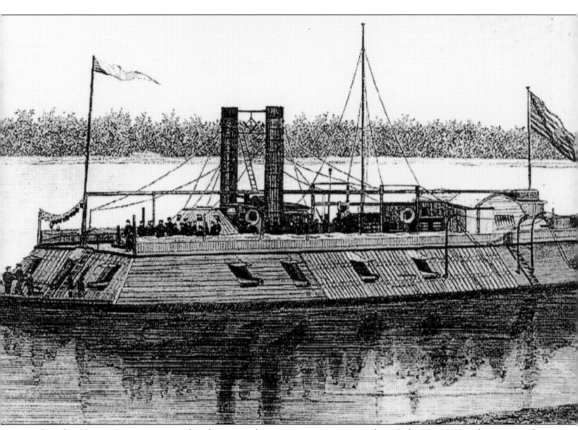

On the Yazoo River just south of town, a historic event occurred on July 12, 1863, when one of the first underwater mines was used to sink the Union ironclad USS *Baron DeKalb*, which was on its way to attack Yazoo City. It still rests on the bottom of Lake Yazoo, formerly a part of the Yazoo River. (Courtesy of the Naval History & Heritage Command.)

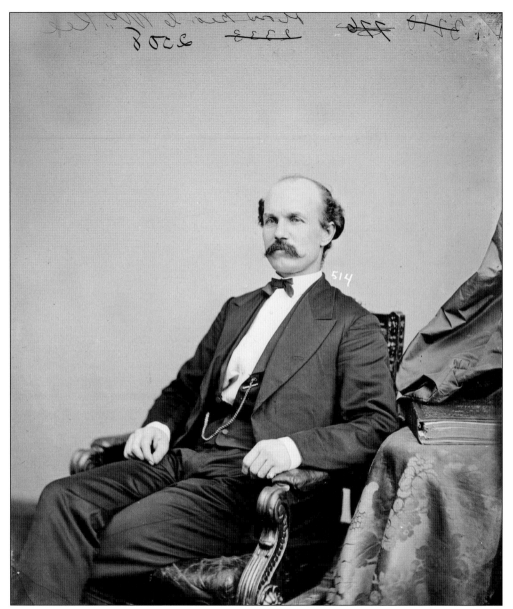

Redoubt McKee, a fortification located at the top of Broadway Hill, was occupied by Union major George McKee and the 11th Illinois Infantry Regiment. On March 4, 1864, it was attacked by Confederate cavalry forces. During the battle, which spilled into the streets of Yazoo City and included action by Union gunboats, Gen. Lawrence "Sul" Ross made three separate demands for the fort's surrender. Each was rejected by McKee, leaving the Confederates to withdraw toward Benton. McKee rose to the rank of general and, after the war, returned to Mississippi and was elected to Congress. (Courtesy of the Library of Congress.)

Early in 1864, a Union garrison occupying Yazoo City included African American troops of the 1st Mississippi Cavalry and the 8th Louisiana Infantry (African Descent). Attacked by Confederates, the Union troops were engaged on the Benton Road and in the main streets of Yazoo City. Shown here is the Yazoo Expedition Historical Marker recognizing the efforts of African American soldiers who fought in the Civil War. (Courtesy of the author.)

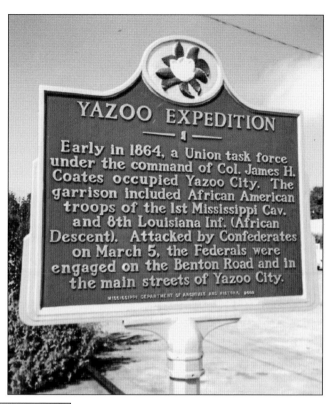

YAZOO EXPEDITION

Early in 1864, a Union task force under the command of Col. James H. Coates occupied Yazoo City. The garrison included African American troops of the 1st Mississippi Cav. and 8th Louisiana Inf. (African Descent). Attacked by Confederates on March 5, the Federals were engaged on the Benton Road and in the main streets of Yazoo City.

MISSISSIPPI DEPARTMENT OF ARCHIVES AND HISTORY, 2000

Lt. Col. William Henry Luse was captain of the Benton Rifles, later Company B, 18th Mississippi Infantry, CSA, upon their organization at Benton, Mississippi, in 1861. He was elected lieutenant colonel of the regiment in 1862. He fought in the Antietam Campaign in 1862 and at Chancellorsville in 1863 and was captured at Gettysburg in 1863. Luse practiced law in Yazoo County and served in the Mississippi Legislature for many years. (Courtesy of the Library of Congress.)

Union forces burned the 1850 William Nichols–designed Greek Revival Yazoo County Courthouse in 1864. Nichols, who also designed the old state capitol building and the governor's mansion in Jackson, as well as the Lyceum building at the University of Mississippi, lived in Yazoo County at that time. The courthouse records had been removed and hidden to prevent their destruction. The records and court were held for a time at J.J. Michie's Exchange Bank before being moved to Wilson's Hall. The Reconstruction-era courthouse was built in 1872 and is still in use today. The building is a hipped-roof, stucco-over-brick structure. An octagonal cupola housing the town clock is a notable feature of this Beaux-Arts Classical building. (Courtesy of Ricks Memorial Library.)

Albert T. Morgan, a Union veteran, carpetbagger, and devout abolitionist, moved to Mississippi in search of wealth and social reform. He served as a state legislator and sheriff of Yazoo County during Reconstruction. Morgan received national attention when the resurgent Democrats took over the county government and forced him to flee. He then wrote a unique narrative of the Reconstruction period, *Yazoo; Or, On the Picket Line of Freedom in the South*, told by a man deeply convinced of the rightness of his cause—the inherent equality of all men, black and white. (Courtesy of the Angela Morgan Collection, Bentley Historical Library, University of Michigan.)

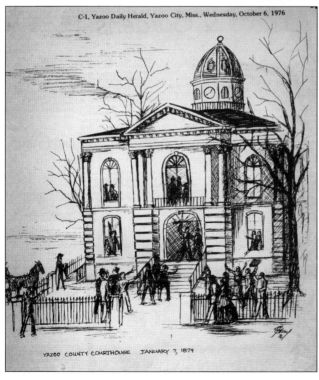

YAZOO COUNTY COURTHOUSE JANUARY 7, 1874

On January 7, 1874, a shoot-out occurred at the Yazoo County Courthouse between the supporters of F.P. Hilliard (the defeated sheriff candidate, who was shot and killed) and A.T. Morgan (the winner of the election, who was tried for Hilliard's murder). In the ensuing violence, several were wounded, and Hilliard was shot in the head and carried outside the courthouse, where he died. At first convicted of murder, Morgan was granted a new trial and remained sheriff until 1875, when he was forced to flee the county. (Courtesy the author.)

Robert I. Martin came to the Liverpool community in 1863. The old Martin house, pictured here in the 1950s, was located in the Dover-Concord community and was the home of Rev. Robert Isaac Martin and his family for many years. Reverend Martin was born in 1899, died in 1997, and is buried in the Dover Cemetery. He was the pastor of Concord Baptist Church from 1935 to 1962. (Courtesy of Ricks Memorial Library.)

The Stubblefield Plantation house was built around 1872 by Simon P. Stubblefield, who returned from the Civil War wounded but made a crop and set about building the house. The actual planning and work was done by "Old Mory," a former slave who had built many of the more pretentious houses in the Black Jack area. It is the third residence to occupy the land patented by pioneer settler William Henry Stubblefield in 1832 on original land grants signed by Andrew Jackson. (Courtesy of Dawn Rosenberg Davis.)

Henry M. Dixon came to Yazoo from Virginia and married Amazon "Amy" Michie of Wilton Plantation in 1865. During Reconstruction, Dixon organized the Dixon Scouts, which played a conspicuous part in restoring white supremacy in Yazoo County. In Morgan's *Yazoo*, Dixon is referred to as "the hornet." During the very contentious election of 1879, James A. Barksdale shot and killed Dixon on Main Street. Dixon's wife, Amy, died the following year, leaving six children orphaned. Friends and supporters of Captain Dixon erected this impressive marker in his and Amy's memory in Glenwood Cemetery. (Courtesy of the author.)

William Henderson Foote, an African American deputy collector with the Bureau of Internal Revenue, was lynched by a mob on December 29, 1883, in Yazoo City after intervening to save a fellow Yazooan from lynching. Three white men had been killed in the event, and Foote and 10 other African American men were jailed and subsequently charged in the deaths. While they were in protective custody in the new county jail on Canal Street, a mob stormed the building. Though outnumbered, Foote fought the mob, but he was felled by several gunshots to the head. William Foote was the first African American federal agent killed in the line of duty. (Courtesy of the Bureau of Alcohol, Tobacco, and Firearms.)

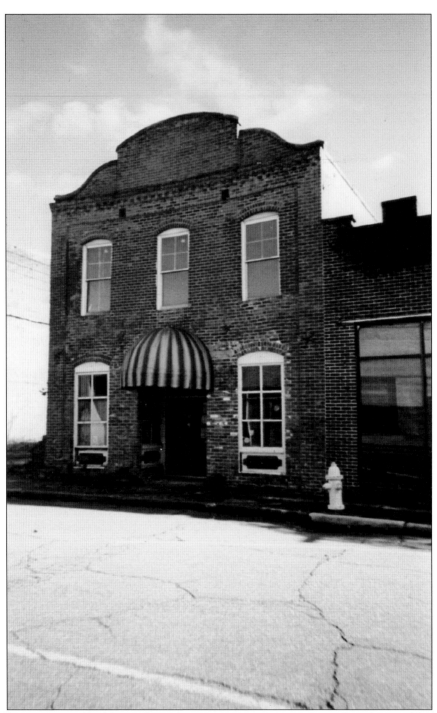

The oldest commercial building still standing in Yazoo City, c. 1870, housed Wash Rose's blacksmith shop following the Civil War. Rose, a former slave, came to Yazoo in 1866 from South Carolina and started his blacksmith business in 1868. He was soon able to purchase this two-story brick building (later known as Henick's Auto Supply), which is one of the few to survive the Great Fire of 1904. (Courtesy of the author.)

This advertisement for "Wash Rose, Horse Shoer & Blacksmith" appeared in the *Yazoo City Herald* in 1882. Rose also advertised carriage repair as a specialty and plow making, sharpening, and repair. Rose was born in 1840 and died in 1912 of pneumonia. He is buried in Glenwood Cemetery. (Courtesy of Ricks Memorial Library.)

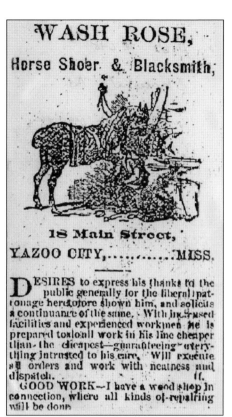

This old photograph shows Main Street as it appeared in the late 19th century. Seen here are the Yazoo City Democrat building, the Yazoo Variety Store, and Campbell & Wilson. (Courtesy of Ricks Memorial Library.)

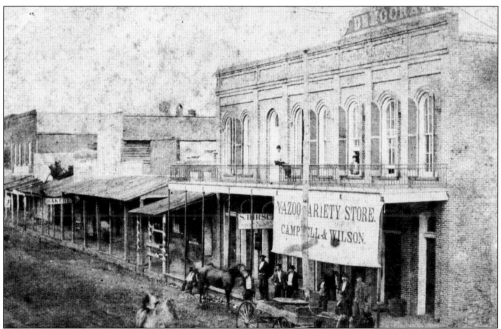

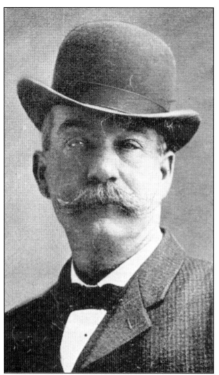

John Lear was president of the Citizens Opera House (which burned in 1904 but was replaced in 1908), founder and president of the Delta Bank & Trust (later Delta National Bank), and owner of Lear Furniture Store. A native of Yazoo, he was born near Anding, Mississippi, in 1853 and died in 1931. (Courtesy of Ricks Memorial Library.)

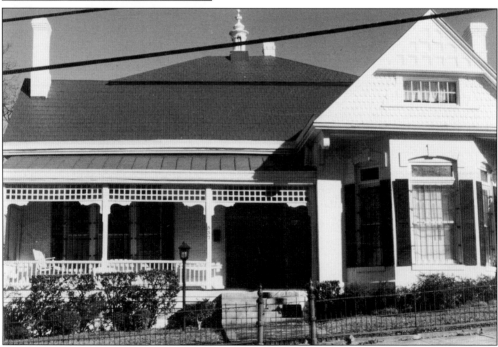

The Lear house on East Broadway is a fine Queen Anne–revival masonry building, the only brick Victorian in Yazoo City. The house was built by John Lear in the 1880s. This photograph dates from 1988, but the house has changed little except in the back, where a two-story addition was constructed a few years ago. (Courtesy of the author.)

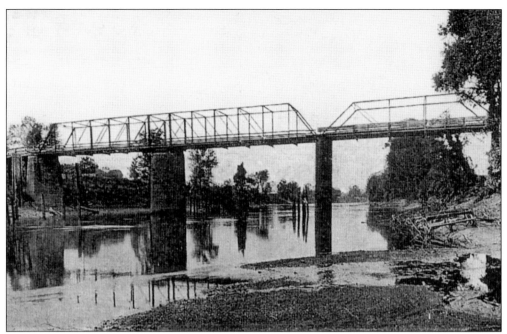

The old Yazoo River Bridge dates from 1882. This was the first iron bridge connecting Yazoo City with the west bank of the river. It was used for local and through traffic until 1937, when a new bridge was completed farther upstream. The old bridge remained in use until a new one was built connecting downtown to Jonestown. (Courtesy of Ricks Memorial Library.)

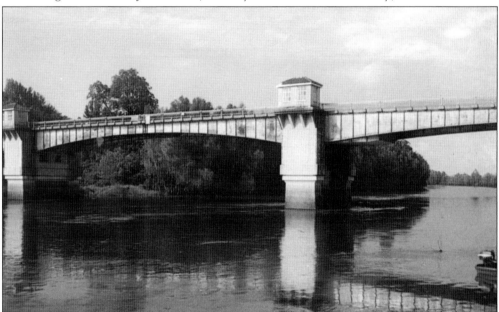

The John Sharp Williams Yazoo River Bridge, constructed in 1937, replaced the old iron bridge that was located adjacent to the power plant. This structure, a drawbridge with center sections that could raise to allow river traffic to pass, was across the Yazoo River on US Route 49 West. In 1988, it was replaced by a new bridge farther upstream, and the old highway is now named Mississippi Highway 149. (Courtesy of Ricks Memorial Library.)

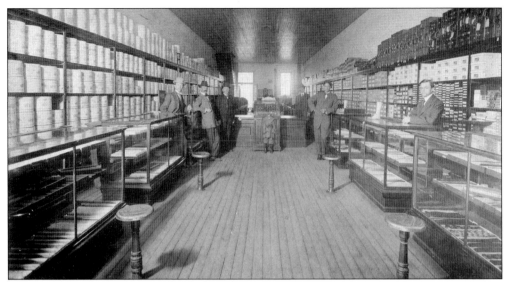

Before the Great Fire of 1904, Lightcap & Company was a dealer in groceries, clothes, and dry goods. The store, located next to the Presbyterian church in the first block of Main Street, burned in the 1904 fire. Shown here is the interior of the C.A. Lightcap Store for Men and Boys, successor to Pugh & Quekemeyer, after the fire and located at 216 South Main. (Courtesy of Ricks Memorial Library.)

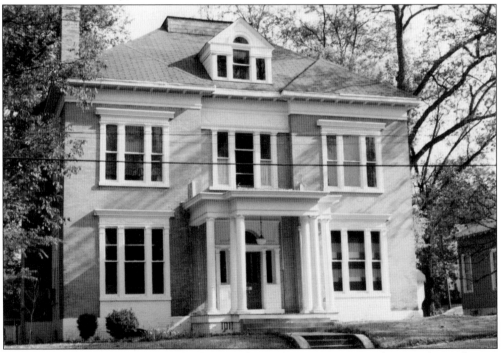

The Lightcap-Holmes house was built around 1895 by Harrison B. Lightcap. The Lightcaps lived here until late 1903 or early 1904 before moving to Rialto Plantation. The Great Fire of 1904 burned down the home of Col. C.E. Holmes, and he immediately purchased the Lightcap residence and moved his family in the same night. The Holmes family occupied the house until Colonel Holmes died in 1931. (Courtesy of Ricks Memorial Library.)

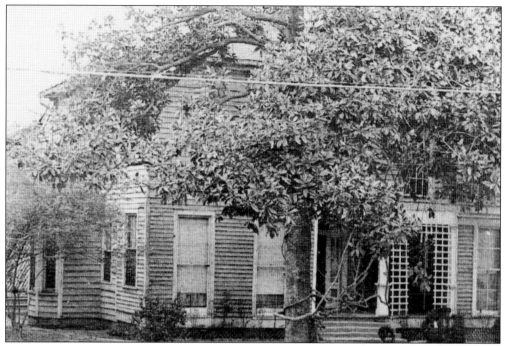

St. Clara Academy and Convent was opened in 1872. Six Sisters of Charity from Kentucky came to Yazoo City in 1871 and established this Catholic school. In 1950, a new convent was built on Washington Street, and three years later, the new St. Clara Academy was opened on the site of the old frame building. This institution played an important part in the cultural life of the city. (Courtesy of Ricks Memorial Library.)

Philomena E. Twellmeyer enrolled at St. Clara Academy in 1872 and a short while later became one of the first to graduate. Here, she poses in her graduation dress. St. Clara Academy operated for more than 100 years. (Courtesy of Ricks Memorial Library.)

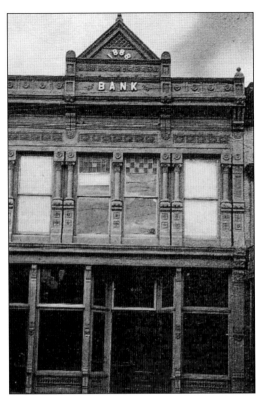

The Bank of Yazoo City has operated continuously since 1876 and is the oldest financial institution in Yazoo City. It was located in the heart of the business district at this location until it burned in the Great Fire of 1904. The bank rebuilt at the corner of Main and Commercial Streets. (Courtesy of Ricks Memorial Library.)

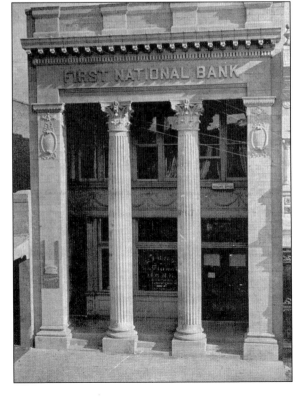

The First National Bank was organized in 1886. This building was erected in 1902, only to burn in 1904. A model of substantial elegance and of beautiful exterior and interior finish, it was described as "the handsomest bank building in the entire state of Mississippi." (Courtesy of Ricks Memorial Library.)

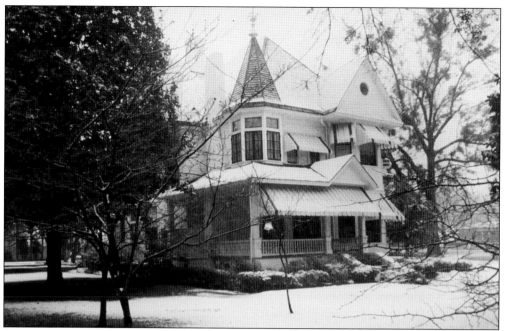

The Payne-Seward house was designed by Elijah E. Myers in the Victorian Queen Ann style. Myers was a leading proponent of public architecture and was known as the greatest builder of state capitols in the latter half of the 19th century. A.M. Payne, the son of the owner of Koalunsa Plantation on the Yazoo River, built this town house in 1891. (Courtesy of Ricks Memorial Library.)

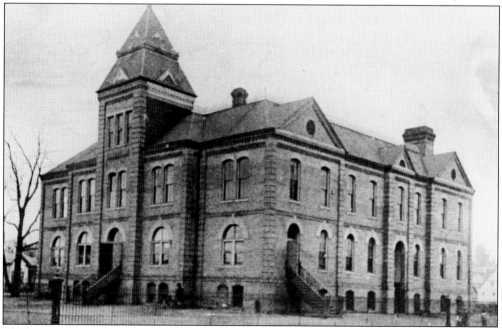

The Main Street School building, known as Public School No. 1, was located where the current building stands. The first permanent records kept for Yazoo City public schools date to 1895 when C.F. Webb was superintendent. This building burned in 1903, a year before the big fire swept through downtown Yazoo City. (Courtesy of Ricks Memorial Library.)

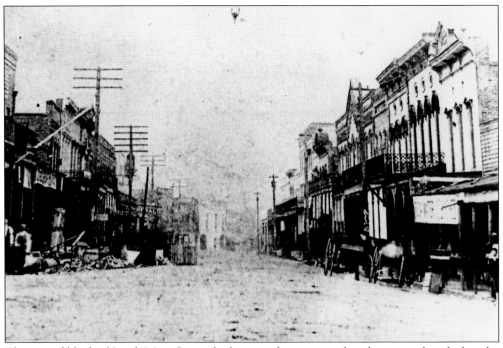

The second block of South Main Street, looking south, is captured in this image from before the turn of the 19th century. Several buildings had iron balconies in those days before the fire. All of this section of town burned. (Courtesy of Ricks Memorial Library.)

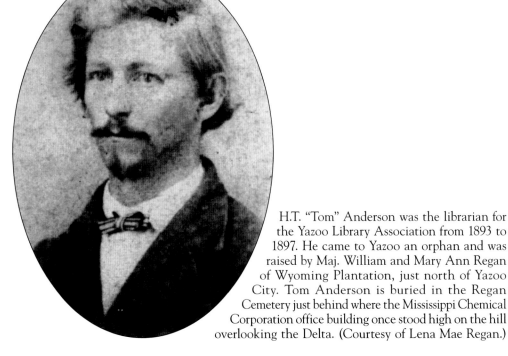

H.T. "Tom" Anderson was the librarian for the Yazoo Library Association from 1893 to 1897. He came to Yazoo an orphan and was raised by Maj. William and Mary Ann Regan of Wyoming Plantation, just north of Yazoo City. Tom Anderson is buried in the Regan Cemetery just behind where the Mississippi Chemical Corporation office building once stood high on the hill overlooking the Delta. (Courtesy of Lena Mae Regan.)

Four

EARLY 20TH CENTURY

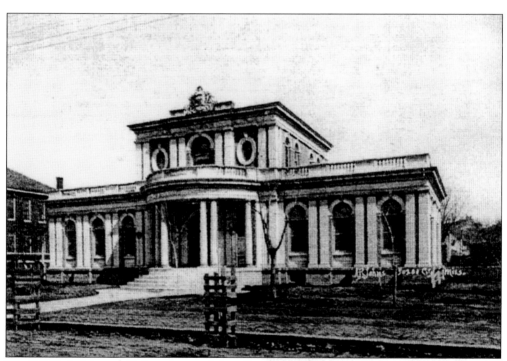

The B.S. Ricks Memorial Library was a gift from Fannie Jones Ricks to the Yazoo Library Association in memory of her husband, Benjamin S. Ricks Jr. Designed by architect Alfred Zucker in 1901, this is the oldest public library building still in use in Mississippi. The first building in the county and the first public library in the state to be named in the National Register of Historic Places, it has also been designated a Mississippi Landmark. (Courtesy of Ricks Memorial Library.)

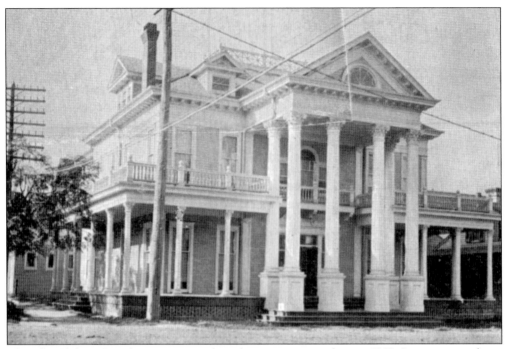

The Elks Club on Broadway was new when this picture was taken in 1902. Just two years later, it would be consumed by fire but rebuilt in the same location. Today, it is called the Manchester and is used as a reception hall. (Courtesy of Ricks Memorial Library.)

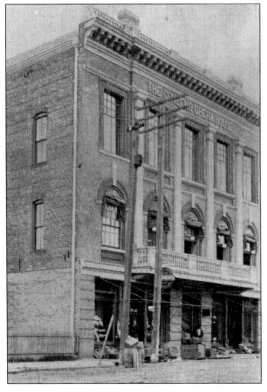

The old Citizens Opera House, erected in 1899, is seen in this photograph from 1902. The opera house's president and guiding force was John Lear. With a seating capacity of up to 1,000 people, the building was unfortunately lost in the Great Fire of 1904. (Courtesy of Ricks Memorial Library.)

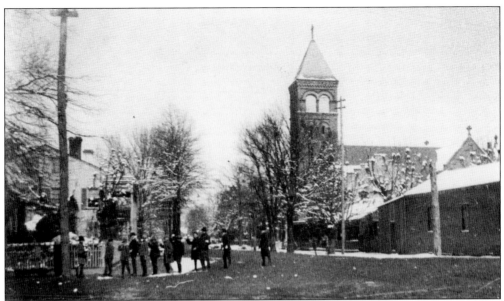

From Main Street and Broadway, looking north, the Catholic church tower is visible next to the Masonic Hall. The rest of the block was composed of small shops, including the Chinese laundry of Sing Lee and the tin shop of Louis William Hamel. This entire block burned in 1904. On the left side of Main Street, the large house is possibly the home of Nannie Devers, which burned in 1904. Snow seems to have fallen, and the young men appear to have snowballs in their hands. (Courtesy of Ricks Memorial Library.)

The Haverkamp house is shown in 1901. This fine, old house stood on West Broadway just behind the Presbyterian church on the corner of Main Street and Broadway. Its raised-cottage style is reminiscent of the Pugh-Blundell House on Powell Street. The Haverkampf house burned in the fire of 1904. (Courtesy of Ricks Memorial Library.)

Rev. Beverly Carradine was born at Altamont Plantation, near Midway, in 1848. After pastorates in New Orleans, St. Louis, and Vicksburg, he toured the United States as an evangelist and wrote over 30 books, including *Yazoo Stories*, *Pen Pictures*, and *Mississippi Stories*. He died in 1931 and is buried in Cedar Hill Cemetery in Vicksburg. Beverly Carradine is the grandfather of John Carradine and great-grandfather of Robert, Keith, and David, the famous Carradine family of actors. (Courtesy of Ricks Memorial Library.)

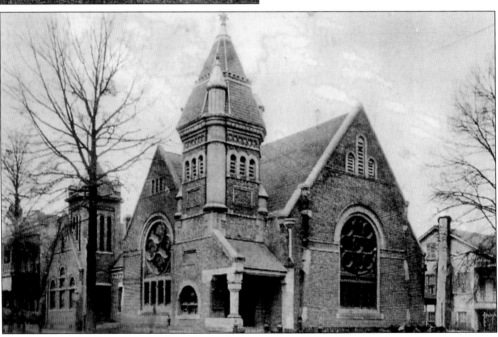

First Presbyterian Church, located on the southwest corner of Main Street and Broadway, is pictured in 1901. To the left on Main Street is the Lightcap store, and on the right on Broadway is the Haverkamp house. All of these buildings burned in 1904. (Courtesy of Ricks Memorial Library.)

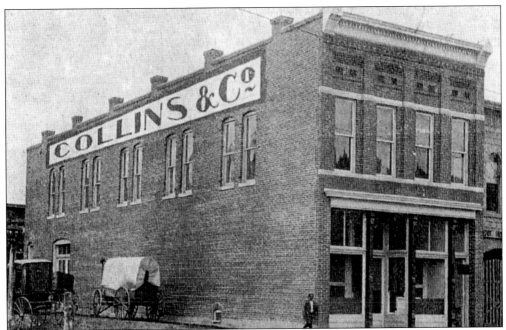

Collins & Co. mortuary, shown in 1902, was located on Jefferson Street. J.W. Gregory became a partner in the firm in 1894. Begun in the late 19th century, it has continued for many years as Gregory Funeral Home. J.W. Gregory Livery, Feed, and Sale Stable was located on the lower end of Main Street after 1904. City hall was built at this location on Jefferson Street in 1906. (Courtesy of Ricks Memorial Library.)

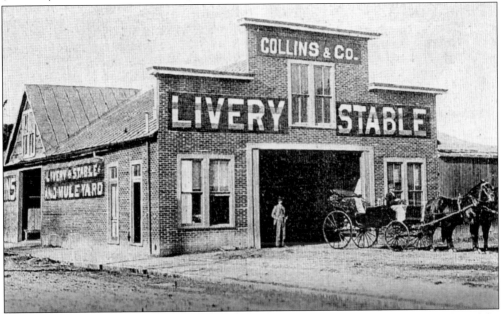

The livery stable of Collins & Co. was located along Washington Street just to the rear of the mortuary on Jefferson Street. The livery business was established in 1849 by A.J. Collins. His son C.A. Collins was operating it when the business burned in 1904, but it relocated farther down the street after the fire. (Courtesy of Ricks Memorial Library.)

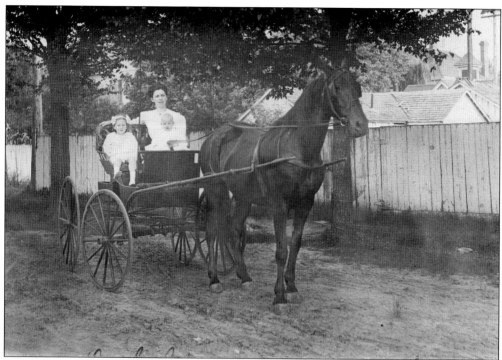

Pearle Rendelman Graeber and young Catherine and baby Charlie are out for an evening drive in their horse-drawn buggy in the early 20th century. Charlie Graeber went on to become a businessman, farmer, alderman, and mayor of Yazoo City. He owned and operated Graeber Brothers Butane Gas Company and Home Ice Company for many years. Born in 1909, Charlie Graeber died at the age of 97 in 2006. (Courtesy of C.L. Graeber Jr.)

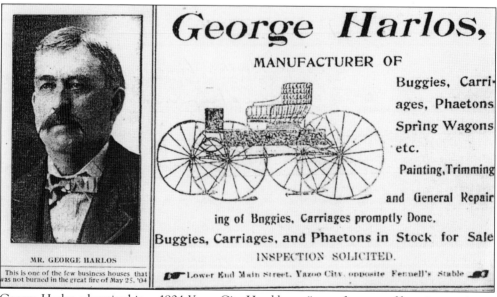

George Harlos advertised in a 1904 *Yazoo City Herald* as a "manufacturer of buggies, carriages, phaetons, spring wagons, etc." He was located on the lower end of Main Street, and his business did not burn in the fire of 1904. (Courtesy of the *Yazoo City Herald*.)

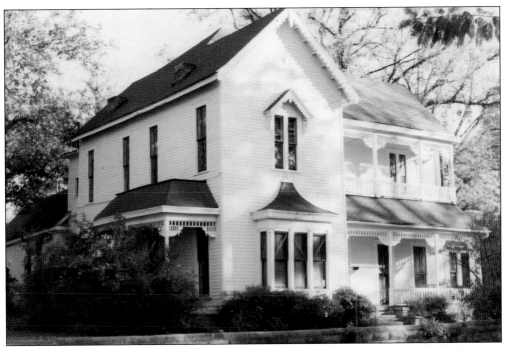

The c. 1890 Norman house began as a one-room structure as early as 1860 but was added onto to make the High Victorian Gothic–style structure seen here. The house is a two-story multi-gabled frame residence and was owned by the Norman family from about 1890 until 2000. (Courtesy of Ricks Memorial Library.)

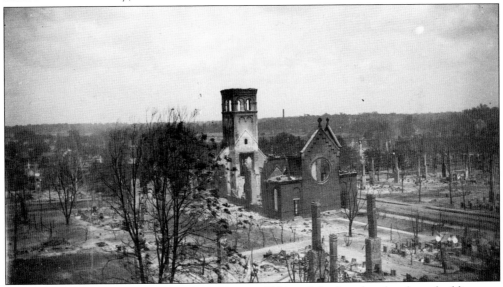

The first Catholic presence in Yazoo County was in 1844, and the first church, a frame building, was built in the 1850s. The yellow fever epidemic of 1853 almost wiped out the Catholic congregation. In 1895, a new brick church was constructed; it was destroyed by fire in 1900, and a new building was dedicated in 1902. St. Mary's Catholic Church was again consumed by fire on May 25, 1904, and the tower and rear wall were all that remained the next day. This picture was taken from the dome of the courthouse, which was spared. (Courtesy of Ricks Memorial Library.)

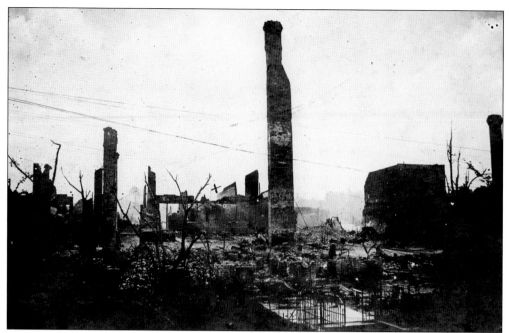

The Great Fire, which burned much of the business and residential districts of Yazoo City, started in the Wise family home on Mound Street in the back of the main business district. A strong wind spread the fire quickly to other buildings. This picture shows some chimneys and an ornamental iron fence remaining at the Wise house. (Courtesy of Ricks Memorial Library.)

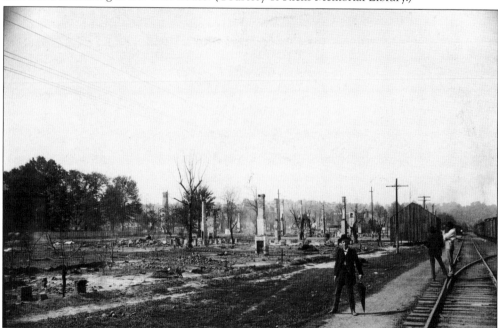

Col. C.E. Holmes, who lost his home in the fire, stands near the railroad tracks with the ruins of Yazoo City in the background. Yazoo City lost within a few hours 324 buildings. Two-thirds of the assessed valuation of all the real and personal property was lost, and between 2,500 and 3,000 people were directly affected by the fire. (Courtesy of Ricks Memorial Library.)

Glenwood Cemetery, dating from 1856, was given to the city by Capt. John Willis and his wife, Anne. Many Confederate soldiers are buried in a plot near the creek. An early newspaper article says they died in the Confederate Hospital on South Main Street. Located not far from the fountain in Glenwood in the Odd Fellows section is a grave surrounded by chain links, which is known as "the Witch's Grave." The legend of the witch became famous in a book written by Willie Morris. (Courtesy of Roselynn Soday.)

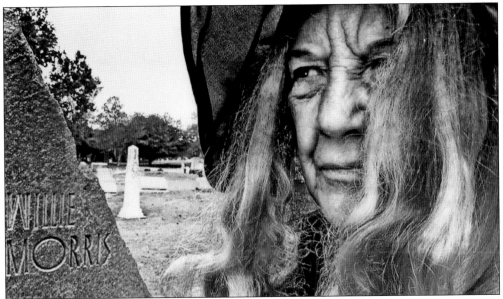

Willie Morris wrote in his book *Good Old Boy* (1971) the legend of the witch placing a curse on the community and saying that she would return on May 25, 1904, and burn down the town. She was buried in Glenwood Cemetery in an unmarked grave with heavy links of chain around it, but after the town did burn on that date, townspeople went to the cemetery only to find the chains had been broken. For the past 50 years, Vay Gregory McGraw, shown here, has played the role of the witch on many occasions. (Courtesy of Dawn Rosenberg Davis.)

Fannie Jones Ricks (1852–1918), an extraordinary woman, was an entrepreneur and philanthropist. She funded both summer school at Ole Miss, which dedicated the 1902 yearbook to her, and the university's first women's dormitory (Ricks Hall, 1903). Sustaining the largest losses of any individual in the 1904 fire, she immediately set to rebuilding her numerous holdings downtown. Goose Egg Park on Grand Avenue was donated to the city by Fannie Ricks, and in 1900, she provided the funds to build B.S. Ricks Memorial Library. (Courtesy of Ricks Memorial Library.)

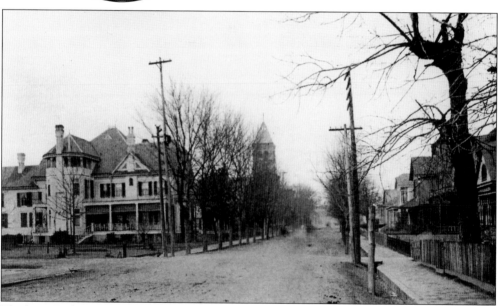

The large Ricks Mansion on North Main Street, seen in a 1901 photograph, was adjacent to the grounds where Ricks Memorial Library would be built. This house and the entire area shown burned in 1904, but the recently constructed library survived in the next block north, as did the new public school next door, which was under construction. After helping to rebuild Yazoo City, Fannie Ricks moved to Mount Tryon, North Carolina, where she lived until her death in 1918. (Courtesy of Ricks Memorial Library.)

Gen. Benjamin Sherrod Ricks Jr. (1843–1899) was a soldier, planter, and businessman. Wounded in battle during the Civil War, he was a first lieutenant in the Mississippi Cavalry. After the war, he became one of the largest planters in the Delta, owning about 18,000 acres of land that included Belle Prairie and Fort Place in Yazoo County. Ricks was appointed major general of the Mississippi militia in 1880 by Governor Lowry. He was both promoter and president of the Cotton Oil Mill and president of the Bank of Yazoo City. (Courtesy of Ricks Memorial Library.)

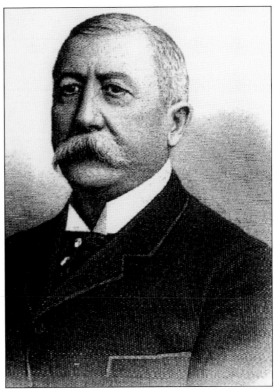

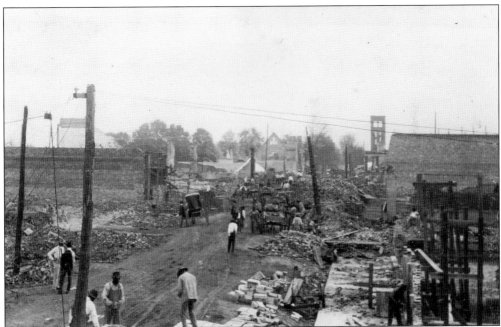

The day after the big fire, Main Street was a pile of burned rubble. This view is looking north toward Broadway, where the ruins of the Presbyterian church are in the center background and the tower of St. Mary's Catholic Church is seen in the right background. One block farther north was the burned-out shell of the Ricks mansion. (Courtesy of Ricks Memorial Library.)

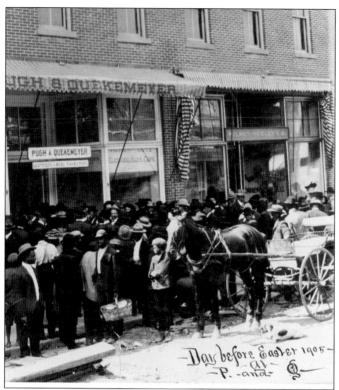

Less than one year after the May 25, 1904, fire, men's clothiers Pugh & Quekemeyer had a grand opening for its new store on Main Street. Here, a crowd gathers out front on the day before Easter in 1905. (Courtesy of Ricks Memorial Library.)

The old Fountain Barksdale residence, on the corner of Broadway and Mound Street, was owned at the time of the big fire by Barksdale's daughter, Louise Barksdale Craig. Seen here in a picture taken shortly before or after the fire, this house was the only one in that part of the city to escape destruction. The home was razed in 1919. Standing on the fence are Allan Craig; his nurse, Claudia Cheeks; and Emily Craig. (Courtesy of Ricks Memorial Library.)

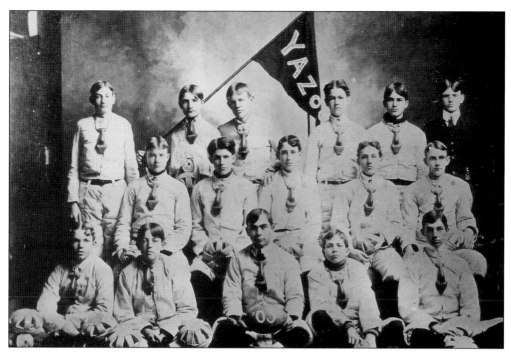

The first high school football game in Mississippi was played in Yazoo City by the local team and Winona High School in 1905. The Yazoo City boys won by a score of 5-0 (scoring was different then). The coach for the team was H.M. Ivy Jr. (Courtesy of Ricks Memorial Library.)

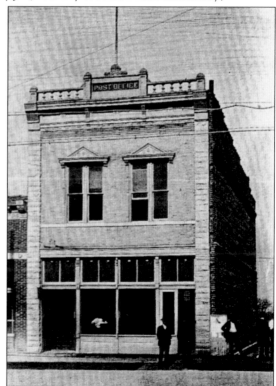

The federal post office occupied this building on Mound Street after the fire. The postmaster at that time was John P. Bennett, who served from 1902 until 1914 and again from 1932 to 1933. The post office was at this location from the fall of 1904 until it moved to new quarters on Main Street and Broadway in 1910. (Courtesy of Ricks Memorial Library.)

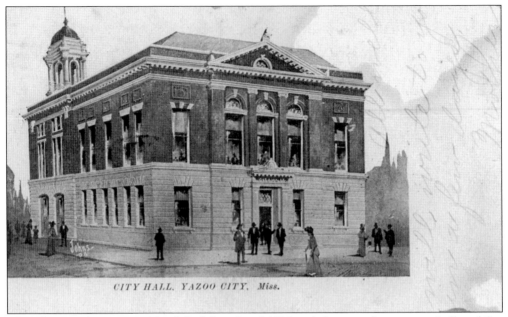

CITY HALL. YAZOO CITY. Miss.

This photographic postcard by A.R. Johns dated 1906 and showing the new city hall and fire department appears to be an architectural drawing. When completed, the building lacked some of the ornamentation seen in this picture. City hall was built on the corner of Jefferson Street and Washington Street where the C.A. Collins Mortuary had been before the fire, and it has been at this location continuously since then. (Courtesy of Ricks Memorial Library.)

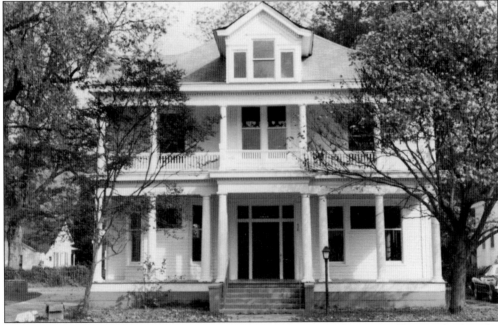

The Great Fire of 1904 started in the Wise family home on Mound Street. Following the fire, the family built this large Colonial Revival house on North Monroe Street. Nearly 100 years later, in 1998, this house was cut in four sections and moved to a new location near Wolf Lake, where it was restored and now looks out over the Delta. (Courtesy of Ricks Memorial Library.)

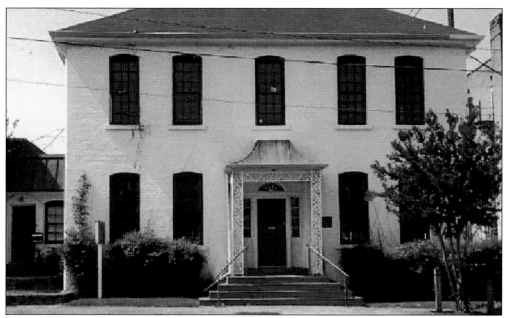

This entire block of Broadway was gutted by the fire of 1904, including the two-year-old Elks Club, which was located where the current building stands today. By 1913, this site above was the Kearney Hotel (which was located close to the depot on Mound Street after the fire) and years later, after the discovery of oil in Yazoo County in 1939, the Southland building. (Courtesy of Roselynn Soday.)

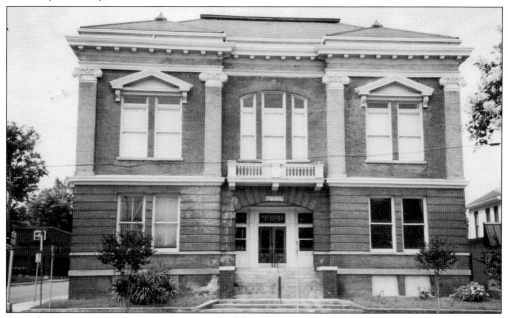

Near the Kearney Hotel on Broadway was the Elks Club, shown here in a contemporary photograph. Directly behind it on Washington Street was the old, three-story Halder Hotel (later Delta Hotel) on Washington Street. Years later, the galleries were removed from the Delta Hotel, and the building had a fake stone facade and a neon light out front. It was demolished for a parking lot. (Courtesy of Ricks Memorial Library.)

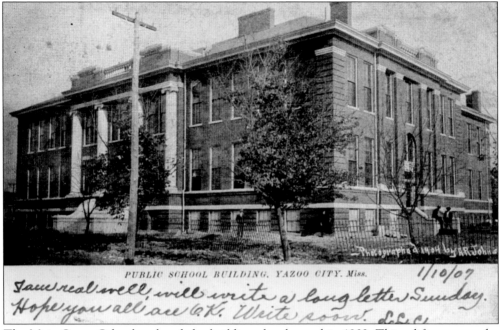

PUBLIC SCHOOL BUILDING, YAZOO CITY. Miss. 1/10/07

I am real well, will write a long letter Sunday. Hope you all are O.K. Write soon. L.L.C.

The Main Street School replaced the building that burned in 1903. This edifice was under construction when the 1904 fire swept the city, but it did not burn. This photograph postcard by A.R. Johns is dated 1904, the year the building was completed. When Main Street School closed as an elementary school in 1976, it became the Triangle Cultural Center and home to the Sam B. Olden Yazoo Historical Museum. (Courtesy of Ricks Memorial Library.)

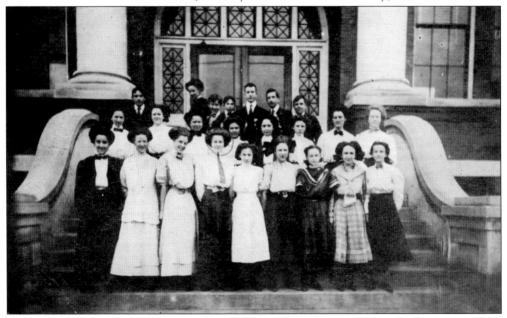

Ninth-graders in 1909 at Main Street School line up for a class picture on the front steps of the building. The Main Street School, constructed in 1904, was the only public school in Yazoo City for white students until 1916, when the first high school was constructed. (Courtesy of Ricks Memorial Library.)

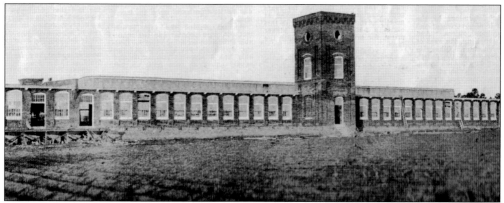

The Yazoo Cotton Yarn Mill opened in 1902 on Grady Avenue at Twelfth Street. Although the company has evolved through many changes since those early beginnings, it has always retained the name Yazoo Mills. Around 1928, the company moved from Yazoo City to New York, and it eventually located in Pennsylvania. Yazoo Mills today is one of America's largest family-owned manufacturers of paper tubes and cores. (Courtesy of Ricks Memorial Library.)

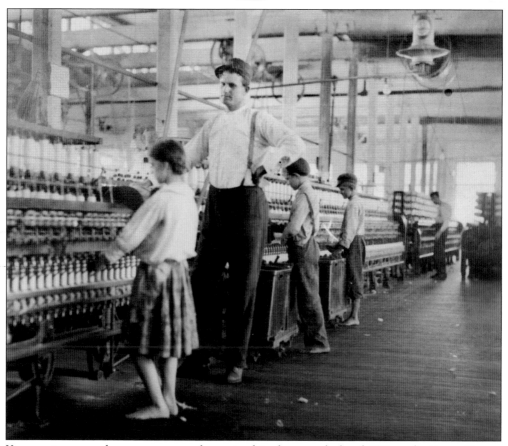

Young spinners and an overseer are shown in this photograph dated 1911 at the Yazoo Cotton Yarn Mill. Children 12 years of age and possibly even younger made up much of the workforce at the mill in the days before child labor laws. (Courtesy of Ricks Memorial Library.)

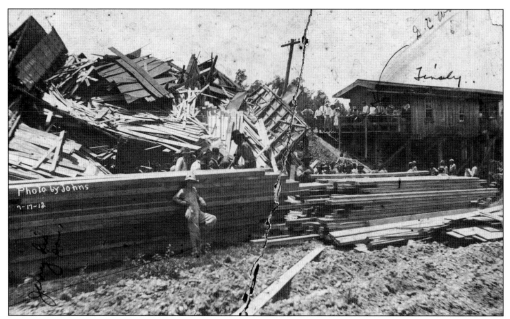

A massive pileup of railroad cars and freight is shown in this photograph by A.R. Johns, dated July 7, 1912, at Tinsley, Mississippi. During the incident, 23 cars derailed and went toward the store, except the two in front, which went in the opposite direction. G.C. Woodruff was asleep in the store when the wreck occurred. In 1939, oil was discovered on Green Woodruff's land, opening the Tinsley Field to oil exploration and development. (Courtesy of Ricks Memorial Library.)

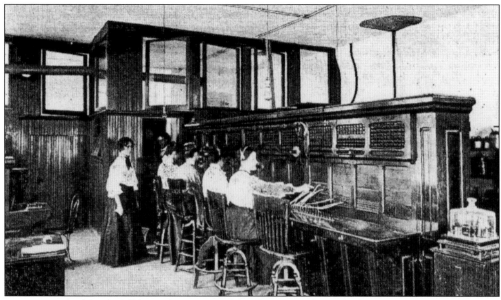

Yazoo City had both full long-distance and local service through the Cumberland Telephone & Telegraph Company. The central office was only ashes after the fire of 1904, and service was suspended. Within hours of the fire, local manager W.T. Bradley had rigged a telephone connection to get messages to Jackson and Greenwood, and within five days, local service was restored. In its offices above the *Sentinel* building, two forces of operators answered calls 24 hours a day. (Courtesy of Ricks Memorial Library.)

Born in Belfast, Ireland, Edward
Luke (1842–1913) was indentured
at the age of 13 and mastered the
jeweler's art and watchmaker's trade.
Luke came to Yazoo City in 1869
and was employed by local jeweler
H.C. Tyler. He made the transition
from employee to employer and for
many years operated Yazoo City's
leading jewelry store. Edward Luke
served as an alderman and was
mayor of Yazoo City for several
terms in the early 1900s. (Courtesy
of Ricks Memorial Library.)

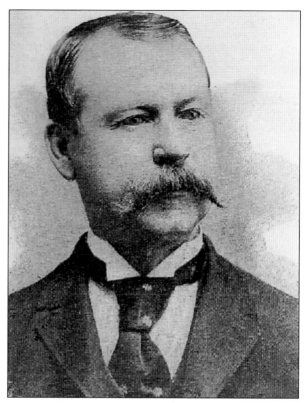

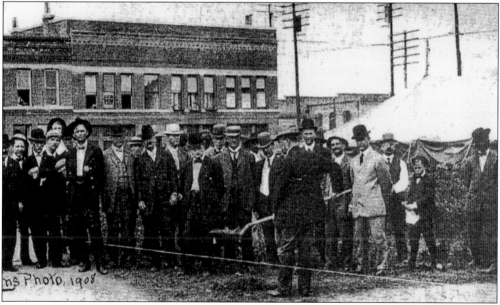

Mayor Edward Luke breaks ground for the new opera house to be located on Washington Street
in 1908. John Lear, president of the opera association, is the third person to the left of the
shovel's tip. The building behind the group of men is the Williams law office on Jefferson Street.
The Masonic building now on the corner had not been built at this time. (Courtesy of Ricks
Memorial Library.)

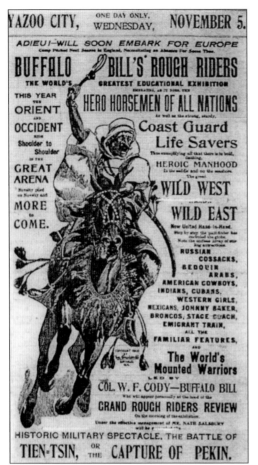

Buffalo Bill Cody's Wild West Show came to Yazoo City in 1902. This poster from the *Yazoo Herald* advertised the coming of Buffalo Bill's Rough Riders for a final appearance before a tour of Europe. There was a grand parade on Main Street prior to two performances. The afternoon show brought in 10,000 spectators, and the night performance, another 6,000 people. (Courtesy of the *Yazoo Herald*.)

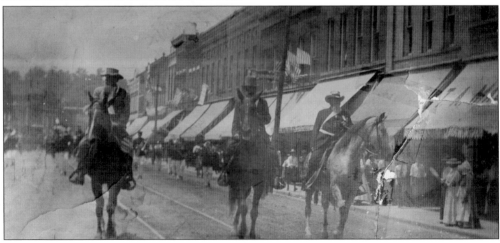

A photograph of a parade on Main Street sometime after 1909 (judging by the streetcar tracks that are still visible in this picture) shows men on horseback leading the procession. This was possibly a Wild West show, as others besides Buffalo Bill were touring the country at that time. Parades back then started at the end of South Main Street and moved north. (Courtesy of Ricks Memorial Library.)

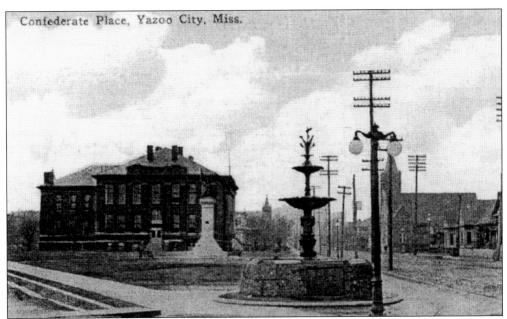

Confederate Place, Yazoo City, Miss.

Crump fountain, at the end of North Main Street in Yazoo City, honors George Crump, whose estate provided funding for school purposes. At the base of the cast-iron fountain, a bronze tablet acknowledges the gift of Crump and the services of Edward Drenning in securing it. This postcard view shows Confederate Place, as it was then known, in 1909. (Courtesy of Ricks Memorial Library.)

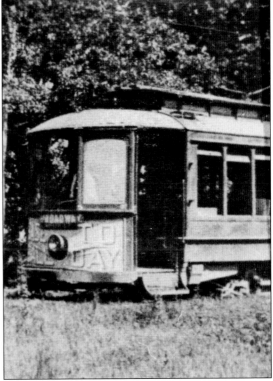

With operations beginning in December 1909, Yazoo City was the first in the state and the second in the country to have a municipally owned streetcar system. All earlier streetcar companies had been privately owned. This old photograph shows the Broadway railcar. Cars would continue from Broadway on to Yazoo Street, up North Street and run out Grand Avenue and make a loop around Goose Egg Park then return downtown to Main Street. (Courtesy of Ricks Memorial Library.)

89

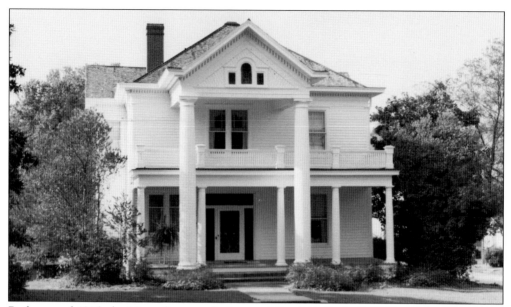

Built around 1915, the Magnolias was the home of Frank R. Birdsall (1859–1930), editor of the *Yazoo Sentinel.* Birdsall became involved in a feud with the mayor of Yazoo City, J.O. Stricklin, who was accused of cattle stealing but exonerated at trial. Birdsall seized the opportunity in the *Sentinel* to publicize that the mayor was under suspicion. The feud ended in one death and one suicide as Stricklin shot and killed Birdsall and then went to Stricklin's son's funeral home and shot himself in the heart. (Courtesy of Ricks Memorial Library.)

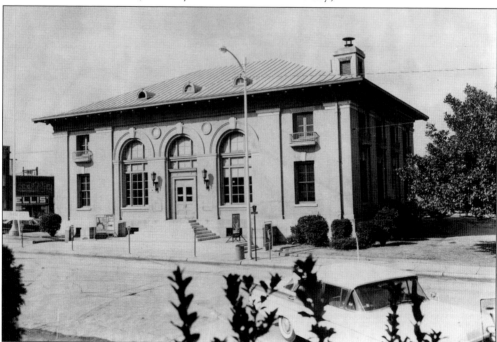

Built in 1910, the federal post office is shown at its location on Main Street and Broadway. The post office was demolished in the early 1960s to make way for the new Delta National Bank. (Courtesy of Ricks Memorial Library.)

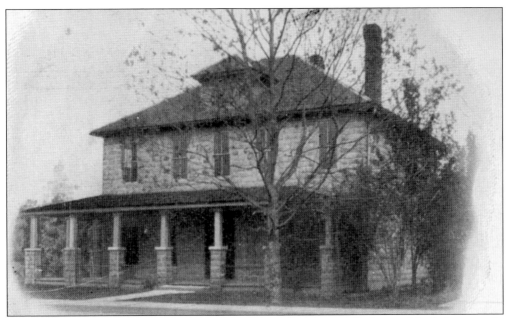

The Lintonia Sanitarium opened in 1915 on Campbell Avenue. The hospital had three wards: surgical, medical, and maternity. Drs. W.D. McCalip, J.B. Anderson, and J.I. McCormick, three of Yazoo City's best-known surgeons and physicians, were the founders. The facility also had a training school for nurses. This building later became an apartment house before being torn down. (Courtesy of Ricks Memorial Library.)

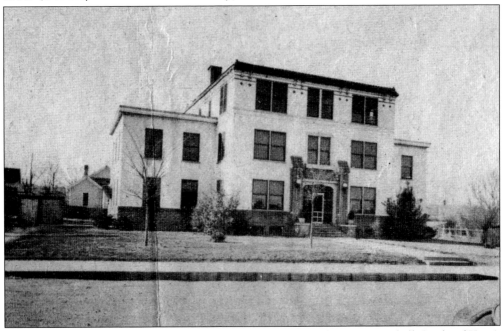

The Yazoo City hospital on Fifth Street was new in 1922. The Mary Brickell Circle of King's Daughters assumed operation of the hospital in 1930. As this building became outdated, King's Daughters Hospital opened in its new location on Grand Avenue in 1955. The old hospital was torn down in 2006. (Courtesy of the *Yazoo Herald*.)

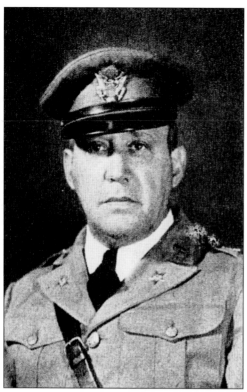

Louis J. Wise, a soldier in both World War I and World War II, was born in Yazoo City in 1892. He embarked for France in May 1918 and was assigned as captain adjutant until 1919. Serving in the National Guard from 1921, he was promoted to lieutenant colonel in 1927. He served in World War II from 1940 until 1945 and then returned to the Mississippi National Guard, where he was promoted to colonel in 1949 and to brigadier general in 1952. (Courtesy of Ricks Memorial Library.)

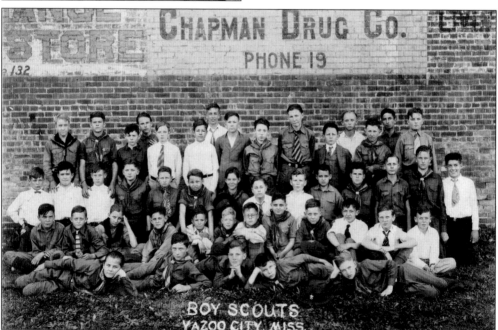

The Yazoo City Boy Scouts of America troop is shown next to the Chapman Drug Co. building in 1929. Troop No. 1 was organized in 1911 in Yazoo City as Mississippi's first Boy Scout troop. N.F. Hennington was its first Scoutmaster. Scoutmaster N.S. Adams, a local historian who wrote an early history of Yazoo, was a longtime troop leader. (Courtesy of Ricks Memorial Library.)

This old house in Anding, Mississippi, was once occupied by Dr. L.C. Elliott (1854–1908); his wife, Richie; and their children Mary Elliott and Joseph Harry Elliott. Dr. Leonard Cheek Elliott was born in Alabama and practiced medicine in Anding. He is buried in Fletcher's Chapel Cemetery. Mary Elliott (1892–1979) married Jonas Patrick Edwards (1892–1918), who died from Spanish influenza at the age of 26. (Courtesy of Mary Edwards Brister.)

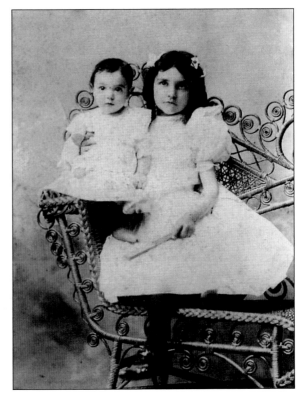

The Elliott children, Joseph Harry and Mary Elizabeth, were photographed at Carroll's Art Gallery in Yazoo City. Joseph Harry Elliott is the father of Mary Cornelia "Doodles" Elliott Ferris, who was born in the Bardwell house on Monroe Street in Yazoo City. Mary Elizabeth Elliott Edwards was the mother of Mary Edwards Brister (1917–2012) and Jonas Patrick Edwards Jr. (Courtesy of Mary Edwards Brister.)

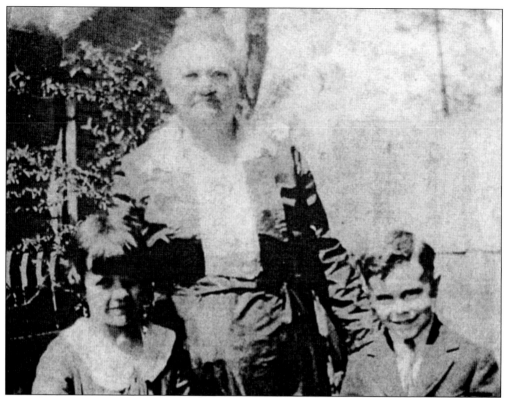

Mary Richardson "Richie" Bowman Elliott and her grandchildren Mary Edwards and Jonas Patrick Edwards Jr. are pictured at the Anding house in the early 1920s. Jonas Patrick Edwards Jr. (1898–1937) died at the age of 19 from a football injury. (Courtesy of Mary Edwards Brister.)

Anding School, named for Martin Anding, first was established in 1916 with Anding, Shilo, and part of Bennett school combining. The combined high school and elementary building in Bentonia was erected in 1929. An annex was added in 1949. The name was changed to Bentonia High School in 1961, and the institution later consolidated with Gibbs High School to become Bentonia Gibbs. The main buildings on campus have been demolished. (Courtesy of Ricks Memorial Library.)

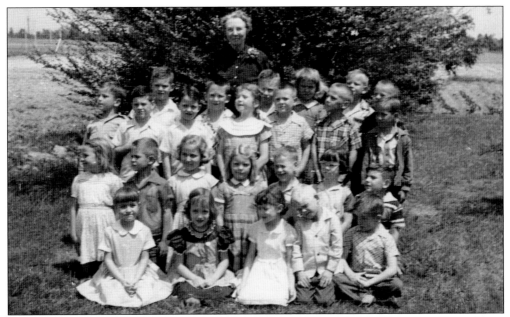

Clyde East Kelly was a longtime teacher of first grade at Anding School in Bentonia. She is shown standing in the rear of this group picture of the last class she taught before retiring in 1953. Wife of A. Benjamin Kelly, she was born in 1884 in Wesson, Mississippi, and died in Yazoo City in 1973. She is buried in Glenwood Cemetery in Yazoo City. (Courtesy of the author.)

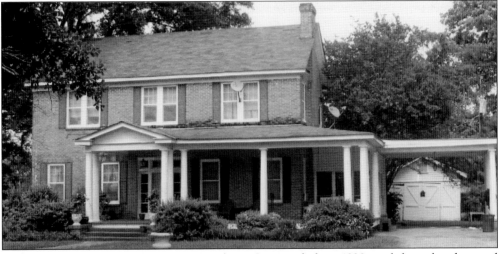

The town of Bentonia was known as Pritchetts Crossroads from 1828 until the railroad arrived in 1883. The name was changed to honor Bentonia Johnson, whose family had owned part of the land the town was built upon. Much of the property originally belonged to the Cannon, Rosenberg, and Johnson families, who gave land for the town site. Another early family was the Hancocks, who operated the Bentonia Hotel from 1906 until it burned in 1932. M.T. Link and his family came to Bentonia in 1902 and played a large part in the development of the town. V.M. Cannon and M.H. Rosenberg, pioneer settlers, also gave land for the right-of-way for the railroad. Gilruth Sessions Cox, born in 1879, married Meta Cannon and had a son, William Cox, who served as mayor of Bentonia. The Cannon-Cox home, shown here, dates from around 1880. (Courtesy of Charlie Carlisle.)

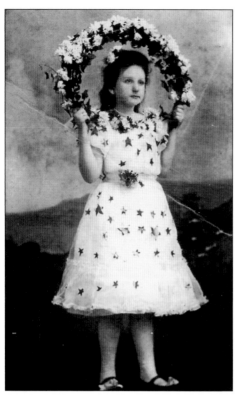

Imogene Hundley Whitehead (1892–1953) was photographed around 1900 in a costume, possibly for a school play. She was the second wife of Dr. John Ignatius McCormick (1872–1939), who was first married to Imogene's sister Susie Whitehead. Imogene and Susie were the daughters of R.M. and Imogene (Kirk) Whitehead of Bentonia. Dr. McCormick, a Yazoo City physician, was a founder of the Lintonia Sanitarium and was the county health officer. (Courtesy of Barbara Allen Swayze.)

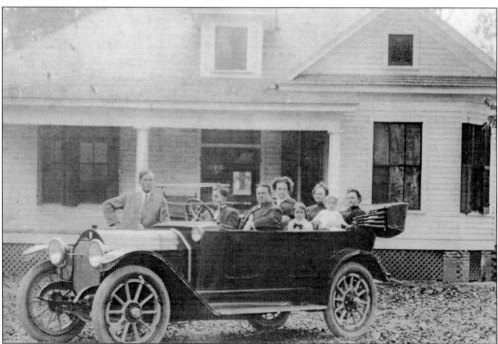

The Whitehead and McCormick families are pictured in Bentonia around 1911. The house, now known as the Whitehead-Carlisle house and often called "Shadow Grove," was built about 1906. (Courtesy of Barbara Allen Swayze.)

The William Cox family of Bentonia is shown at Ingram's Shoe Store in Yazoo City with proprietor Earl Ingram in this image from about 1960. From left to right are Eugenia Cox, Martha Cox, Nancy Cox, William Cox, Earl Ingram, and Bill Cox. (Photograph by Stanley Beers, courtesy of Ricks Memorial Library.)

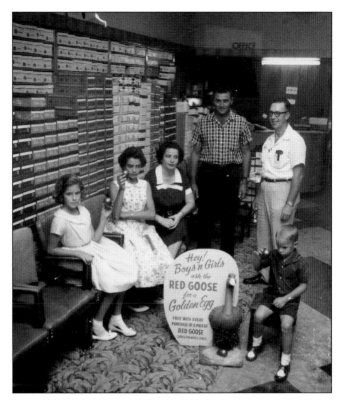

In 1923, Satartia and Martin schools consolidated with other small schools being added until 1930, including Mechanicsburg and Phoenix High Schools. The Satartia High School building was erected in 1929. The old high school building is shown here in 2003 as it was being torn down. (Courtesy of the author.)

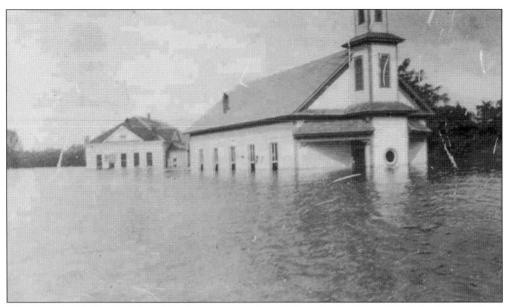

The Satartia Methodist Church had water up to the windows in the Great Mississippi River Flood of 1927. This Gothic-style church was dedicated in 1896 and was rebuilt after the flood. The first clergyman was Charles C. Evans, who served from 1896 to 1900. This building was replaced years later by a new church. (Courtesy of the Yazoo Historical Society.)

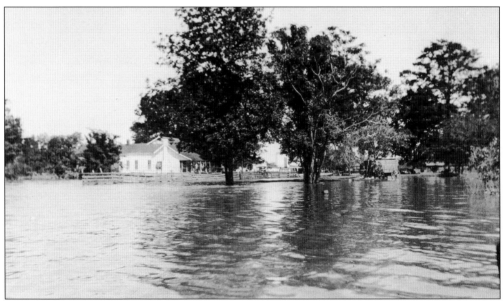

When the Mississippi River levee broke in 1927 above Greenville, the Delta region was inundated with water to the foothills of the bluffs in Yazoo City. The Great Flood forced thousands of people from their homes in the Delta to higher ground, and many refugees were housed in tent cities. Shown here is the Schaefer house at Tokeba Plantation with floodwaters surrounding it. (Courtesy of Ricks Memorial Library.)

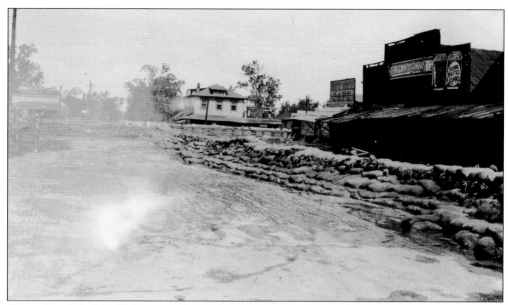

Owned by Col. C.E. Holmes and located on Broadway at the railroad tracks, Holmes Quarters was sandbagged but still took in water in the flood. In September 1937, the *Yazoo Herald* reported, "The Holmes Quarters, a landmark in Yazoo City since the Great Fire of 1904, will soon be no more. The old frame buildings fronting on Broadway and Mound Streets will be demolished to make way for construction of Auto Supply Company." According to old-timers, Colonel Holmes would go down to Holmes Quarters each day and sit. (Courtesy of Ricks Memorial Library.)

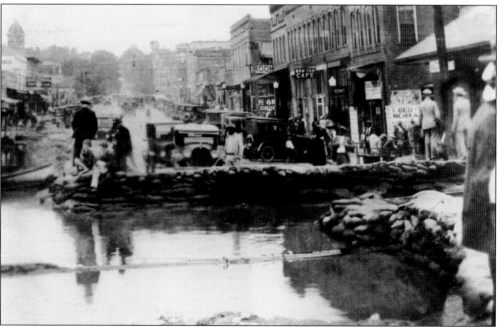

Along the railroad tracks on Broadway, sandbags were used to hold back the floodwaters so that trains could come through town. This scene shows the depot on the far right side. The old Bon Ton Café is also visible. Holmes Quarters is on the left, and the courthouse dome in the distance is on the far left side. (Courtesy of Ricks Memorial Library.)

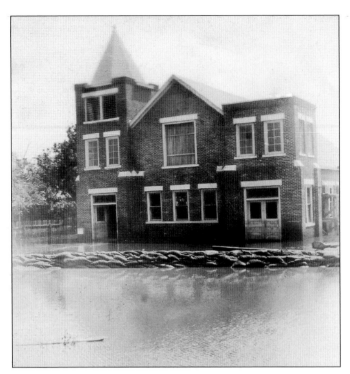

The Mount Vernon Missionary Baptist Church, located on Canal Street, was built in 1925, but the congregation is one of the oldest in town. The fire of 1904 destroyed the first church building on North Main Street. Seen here in the Flood of 1927, the church is surrounded by sandbags. The water had receded four and a half feet when this picture was taken. (Courtesy of Ricks Memorial Library.)

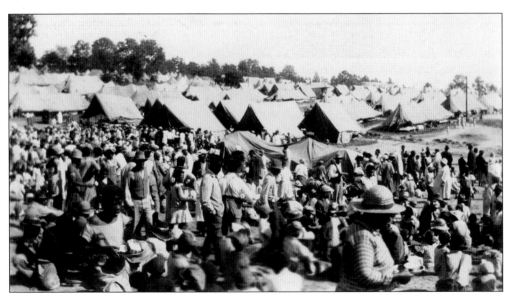

Camp Quekemeyer, named for Col. John George Quekemeyer, was located atop the hill on Wyoming Plantation, north of Yazoo City. Within a week, over 9,000 people found shelter here. At the peak of the camp, there were about 12,500 refugees. During the 42 days that the camp existed, 17 people died, and there were 29 births there. There was only one death attributed to drowning in the flooded area of Yazoo County. (Courtesy of Ricks Memorial Library.)

John George Quekemeyer (1884–1926) was born in Yazoo City. Shown here in his West Point cadet uniform in 1905, Quekemeyer entered the US Military Academy in 1902 and graduated in 1906. Major Quekemeyer distinguished himself in the military, being appointed personal aide-de-camp to Gen. John J. Pershing during World War I. He held the temporary rank of colonel and was wounded in Argonne Forest in 1918. Awarded the Distinguished Service Medal and many decorations from the Unites States and other countries, he died in 1926 at West Point before he could take command as commandant of cadets at the academy. (Courtesy of Ricks Memorial Library.)

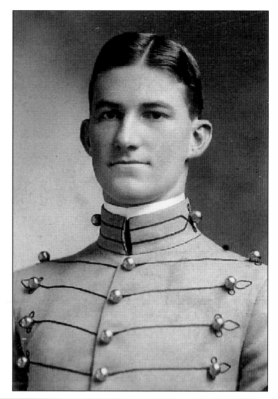

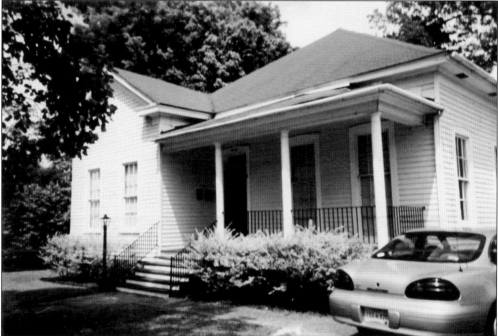

The Quekemeyer house on North Washington Street in Yazoo City is a one-story, hip-roof frame house that was home to the Quekemeyer family. They came to live here after the Great Fire of 1904 destroyed their earlier home on South Washington Street. (Courtesy of the author.)

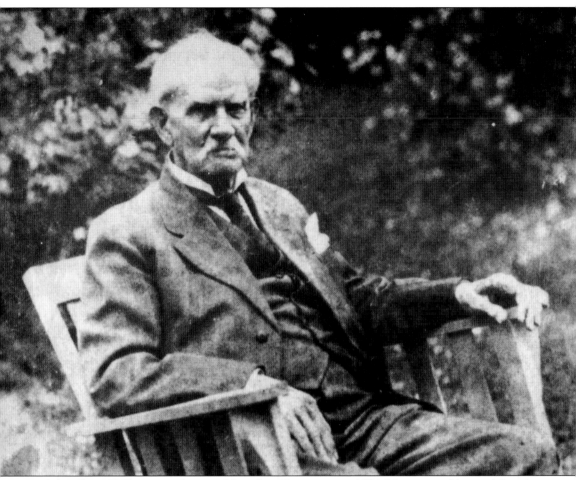

John Sharp Williams was born in Memphis, Tennessee, in 1854. He practiced law in Memphis and in Yazoo City. Williams was elected to Congress in 1893 and was never defeated in a race for public office. He served in the House of Representatives from 1893 until 1909 and was the house minority leader from 1903 to 1908. He served as US senator from Mississippi from 1911 until 1923, when he declined to run for a third term. He retired to his family's Yazoo County plantation, Cedar Grove, near Benton, Mississippi, where he died in 1932. He is buried in the family cemetery there, which holds the graves of most of the family, including John Sharp, an early Yazoo County pioneer and the senator's grandfather. (Courtesy of Ricks Memorial Library.)

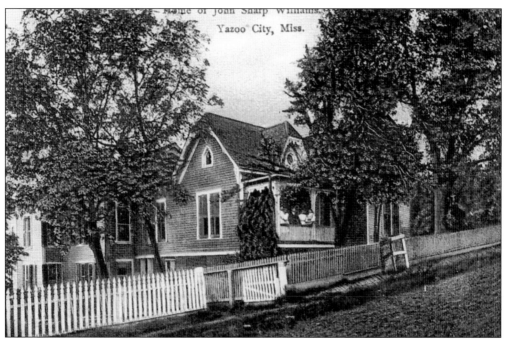

The Yazoo City town house of Sen. John Sharp Williams is shown in a postcard before a storm in 1925 (the newspaper called it a cyclone) destroyed the front porch. The house and roofline were remodeled to a simpler form without a porch, and the building is still standing on the corner of Madison and Ward Streets. Some of the timbers from the renovation were used in constructing the Woolwine house on Grand Avenue at Goose Egg Park. (Courtesy of Ricks Memorial Library.)

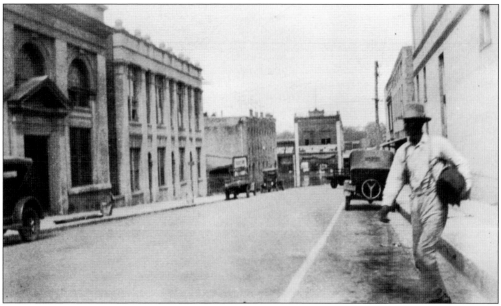

Looking west, Commercial Street in Yazoo City is shown in the 1920s. Behind the man crossing the street is the Wise Brothers building; to the left is the Bank of Yazoo City as it originally looked before modernization sometime in the 1950s. Behind that is the old PSC building, and at the end of the street is the old post office on Mound Street. (Courtesy of Ricks Memorial Library.)

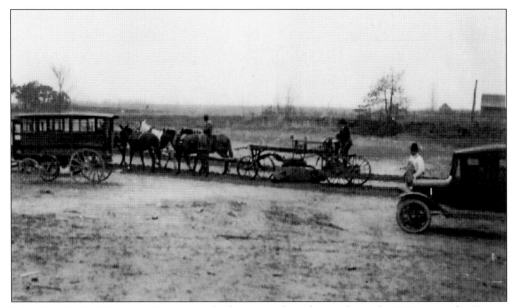

John Ralph "Raife" Regan drives a mule-drawn road grader in the early 1920s near the Fugate School. Regan built many of the county roads using convict labor, mules, shovels, picks, and dynamite. He was a descendant of William Regan, who came to Yazoo County before 1846 and built a home on Wyoming Plantation. A lawyer who served in the legislature from Yazoo County, William Regan was instrumental in having the county courthouse moved from Benton to Yazoo City in 1850. (Courtesy of Lena Mae Regan.)

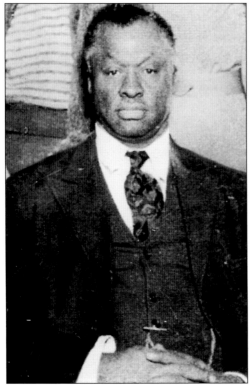

T.J. Huddleston Sr. (1876–1959) was a prominent African American entrepreneur, community leader, farmer, and educator who owned dozens of funeral homes in Mississippi. Huddleston founded the Afro-American Sons and Daughters, a fraternal organization, and four years later in 1928 he opened the Afro-American Sons and Daughters Hospital in Yazoo City. (Courtesy of Joseph C. Thomas.)

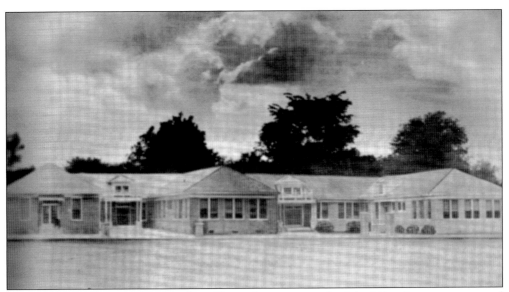

The Afro-American Sons and Daughters Hospital is a one-story brick building that was constructed in 1928. It was the state's first hospital owned and operated by and for African Americans. The Afro-American Sons and Daughters was the largest fraternal insurance organization for blacks in the South. The hospital closed in 1972. (Courtesy of Ricks Memorial Library.)

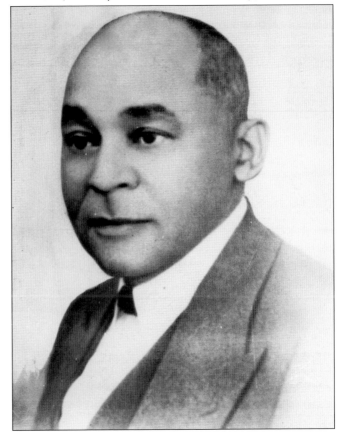

Dr. Lloyd Tevis Miller (1874–1951) started his medical practice in 1893 in Yazoo City. Thomas J. Huddleston Sr. proposed the idea of forming the Afro-American Sons and Daughters to Dr. Miller, and by 1928, they had built the first black-owned and -operated hospital in Mississippi. The L.T. Miller Community Center in Yazoo City honors Dr. Miller. (Courtesy of the Yazoo Historical Society.)

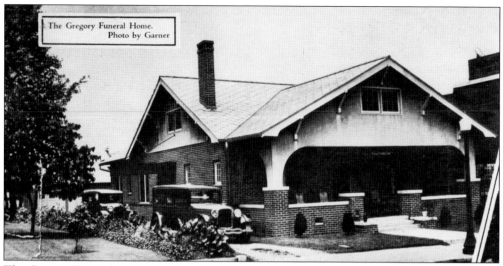

The Gregory Funeral Home, shown in 1929, is the oldest mortuary business in the state, having been established as C.A. Collins & Company. J.W. Gregory became a partner in 1894. This building on Main Street dates from 1926 and is considered the first designed and built as a funeral parlor in Mississippi. (Courtesy of the *Yazoo Herald*.)

Elizabeth Bardwell is pictured at the wheel of her new Buick sedan with several unidentified friends in 1929. The automobile was a gift on her graduation from Belhaven College by her parents, James A. Bardwell Sr. and Cornelia Tyler Bardwell Sr. Buick cars in Yazoo City were distributed through Yazoo Motor Company. C.H. Estes was the manager. (Courtesy of the *Yazoo Herald*.)

Five

DEPRESSION, RECOVERY, AND THE GOOD OLD DAYS

A car crashed into the front of a building on Main Street is symbolic of the country around 1930. The economy was a wreck, the stock market had crashed, people were unemployed, and it was the worst of times. But recovery was on its way, for the country as a whole and for Yazoo in particular. The coming years would see the discovery of oil in Yazoo, World War II, the Korean War, and the good old days of the 1950s. (Courtesy of Ricks Memorial Library.)

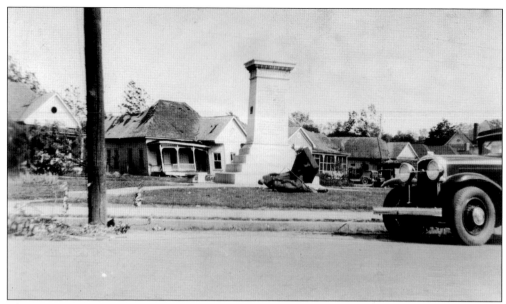

The Confederate Monument, erected in 1909, toppled to the ground in the 1933 tornado that struck Jonestown and the downtown portion of Yazoo City. Trinity Episcopal Church was demolished as the storm tore through, leaving only the altar with its beautiful stained glass still standing. Two deaths, more than 50 injuries, and heavy property damage were reported as Jonestown was practically wiped out as were Yazoo City's freight depot and a block on Water Street and West Powell Street. (Courtesy of Ricks Memorial Library.)

These young ladies were selected by the Yazoo Negro Fair Association to enter their annual beauty pageant in 1936. Hilta Mosely, holding the silver loving cup, was chosen as the winner. Pictured from left to right are Birdie Reynold, Gloria Mae Johnson, Hilta Mosely, Helen Jackson, Sarah Fouche, Beatrice Jones, and Anjello Webber. (Courtesy of Ricks Memorial Library.)

Charles Reid Hogue (1925–1998),
longtime Yazoo City physician, is
shown as a young man in about
1939. Hogue attended school in
Eden and Yazoo City and later
graduated from Millsaps College
and received his medical degree
from Tulane University School of
Medicine. Dr. Hogue returned to
Yazoo City in 1955 and was a general
practitioner and surgeon for 43
years in Yazoo County. (Courtesy
of the Yazoo Historical Society.)

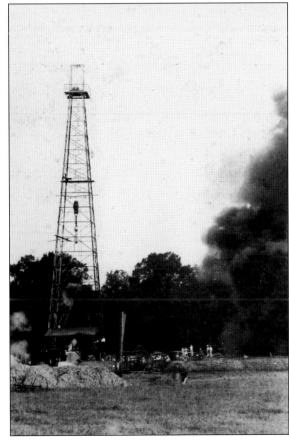

Oil was first discovered in Mississippi
on September 5, 1939, at Woodruff
No. 1 near Tinsley. The well had
been tested on August 29 and when
it came in, oil blew out over the
crown of the derrick. The well was
completed on September 5 and
when put on production flowed
300–400 barrels of 100 percent oil
per day. The surrounding area was
drilled and developed into Tinsley
Field. (Courtesy of the author.)

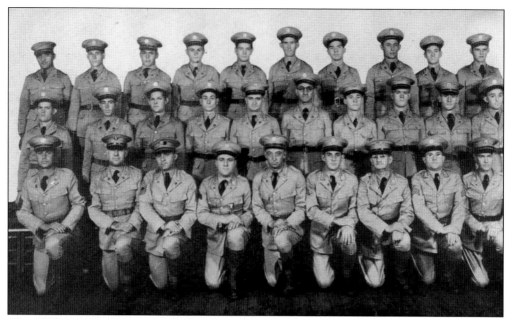

The 155th Infantry Service Company of the Yazoo City National Guard is shown in this 1938 picture. When the United States began mobilizing for World War II, the 155th Infantry Regiment, made up of National Guard units from all over the state, was called to active service. It became part of the 31st Infantry Division. Since it was first organized in 1917, the 31st Infantry Divison was called the "Dixie Division." (Courtesy of Ricks Memorial Library.)

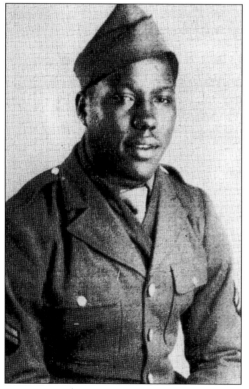

H.A. Scott served in World War II for two years fighting in Europe and has served as commander of the Whitney-Woods American Legion Post. He was principal of the Campbellsville School in Holly Bluff for 13 years. Later, he became director of federal programs for the school system and president of the Yazoo County Fair and Civic League. Herbert Scott was instrumental in establishing the Oakes African American Cultural Center. (Courtesy of the *Yazoo Herald*.)

Herbert Payne "Herbie" Holmes was a nationally known bandleader in the 1930s and 1940s. Holmes organized a band in his high school years known as Herbie Holmes and the Mississippians, which played locally and at the University of Mississippi. He became nationally known, and the Herbie Holmes Band played dates across the United States and was featured on national radio broadcasts. The theme song for the band was "Darkness on the Delta," and Herbie's wife, Nancy, was a featured soloist with the band. (Courtesy of Ricks Memorial Library.)

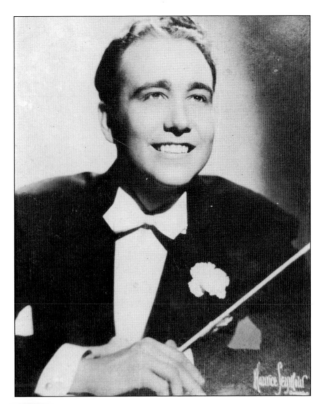

Reuben Davis moved to the Carter community in Yazoo County in 1939. He was the author of *Butcher Bird* (1936) and *Shim* (1953) and also wrote articles and short stories. He married Helen Dick, who collaborated with him on his novels. The family lived in Yazoo County until Davis died in 1966. Reuben Davis's place in the literary history of the South is necessarily limited by the small quantity of his writings, but the quality is of a high standard. (Courtesy of Nicholas D. Davis.)

Henry Herschel Brickell (1889–1952), editor and literary critic, worked as a reporter for various newspapers and became editor of the Jackson, Mississippi *Daily News* (1916–1919). He left Mississippi for New York City, where he was literary editor for the *New York Evening Post* (1934–1939). In 1940, Brickell assumed editorship of the *O. Henry Memorial Award Prize Stories*. Brickell entered government service during World War II and worked at the State Department from 1943 to 1947. (Photograph by Blackwell Studios, courtesy of Ricks Memorial Library.)

Willie Morris, born in 1934 in Jackson, Mississippi, moved to Yazoo City when he was six months old. Morris's relationship to Yazoo City is reflected in his writings about a "sense of place" in his early works such as *North Toward Home* (1967) and *Good Old Boy* (1972). Editor in chief of *Harper's Magazine* and writer in residence at Oxford, Mississippi, Morris wrote two books—*Good Old Boy* and *My Dog Skip*—that were made into movies. Willie Morris received the Governor's Award for Excellence in the Arts in 1994 and the Richard Wright Medal for Literary Excellence in 1996. (Photograph by Stanley Beers, courtesy of Ricks Memorial Library.)

In 1937, the Morris family moved from Jackson into this frame house located on Grand Avenue in Yazoo City. Willie Morris died of a heart attack August 2, 1999, at the age of 64. He is buried in Yazoo City's Glenwood Cemetery, 13 steps south of the Witch's Grave he immortalized in *Good Old Boy*. (Courtesy of Roselynn Soday.)

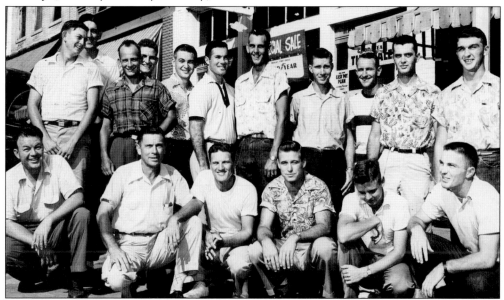

A member of the American Legion baseball team that won the state championship in 1950, Willie Morris also played with the semiprofessional baseball team that he wrote about in *Always Stand in Against the Curve* and *North Toward Home*. This team won the Deep South championship and went to the national competition in Wichita. Morris is shown here, second from the right in the first row, with his head down. Second from the left in the first row is the team coach, John Odum, called "Gentleman Joe" in the books. (Courtesy of the author.)

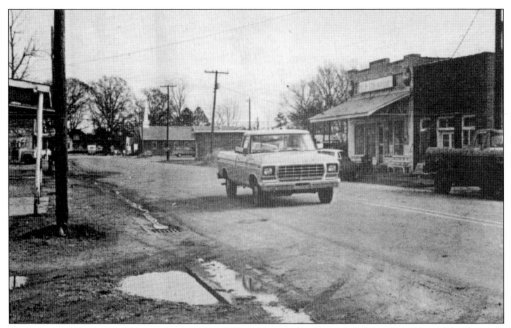

This view of Holly Bluff was taken in the 1970s. Originally part of the Frank Wilson Sharbrough plantation, the town site of Holly Bluff was cleared in the early 1900s. The name of Holly Bluff was given by a steamboat captain because of the large grove of holly trees that grew on the banks of the Sunflower River adjacent to the Sharbrough residence. (Courtesy of the *Yazoo Herald*.)

Matilda Hudson lived in an old house at the juncture of Concord Church Road and Robinett Road. On December 1, 1864, one of the last engagements of the Civil War in Yazoo County was fought at the nearby Concord Church. Sitting on a hill, Hudson's house served in pioneer days as a stagecoach stop and inn. A narrow staircase led upstairs, where travelers would sleep—the rooms for men and women being divided by only a curtain. The house burned in the early 1960s. (Courtesy of Mary Edwards Brister.)

N.D. Taylor (1880–1956) was the principal for 21 years of Yazoo City High School No. 2, also known as the Yazoo City Training School. It was under Professor Taylor's administration that the institution became a 12-grade school. The new high school on Lamar Avenue, built in the 1950s, was named in his honor. (Courtesy of Joseph C. Thomas.)

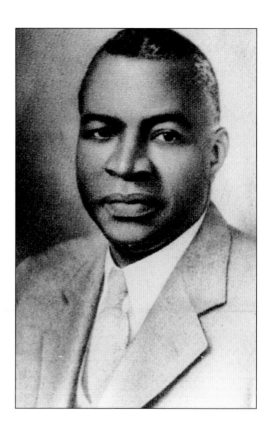

D.W. (David Wilson) Wilburn (1910–2009) was the son of David Orange and Mollie Wilson Wilburn. He married Henrine Woods in 1938. Wilburn served at four colleges and universities: as registrar at Rust College, as acting president of Natchez Junior College, as dean of men at Jackson State University, and as registrar at Alcorn State University. He believed in the importance of education in the lives of all men and women. (Courtesy of the Yazoo Historical Society.)

Mary Louise Taylor Miller devoted 43 years to teaching, retiring in 1979 from the Yazoo City School District. She helped found the Lamar Street Kindergarten, later named in honor of Ann Brooks, and was instrumental in bringing Head Start to Yazoo County, serving as its first director. She was also a commissioner with the Yazoo City Housing Authority and a board member of Ricks Memorial Library. (Courtesy of David Rae Morris.)

Dr. Robert Harrison came to Yazoo City in 1941 and practiced dentistry for many years until his death in 1992. He was appointed by Gov. Bill Waller to the Mississippi Board of Trustees of State Institutions of Higher Learning and was elected the first black president of the board. Mississippi Valley State University named a building in his honor: the Robert W. Harrison Health, Physical Education and Recreation Complex. (Courtesy of the *Yazoo Herald*.)

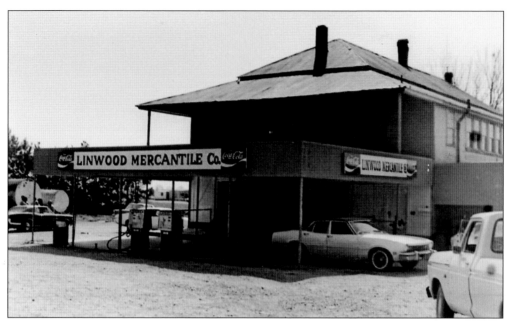

The Linwood Mercantile Company building was first used as a store in Deasonville by E.L. Pepper and Major Brister in the late 1800s. The building was moved to Linwood in 1918. The general store, in many ways the heart of any small, rural community, not only supplied groceries, hardware, and gasoline, but was also a meeting place and an easily recognizable landmark. (Courtesy of the *Yazoo Herald*.)

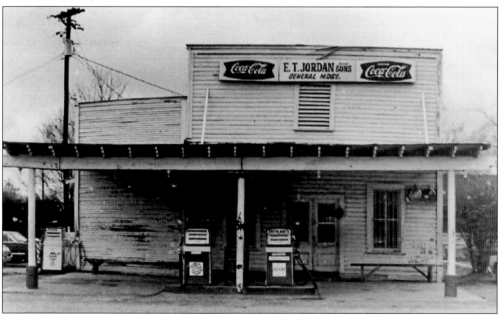

The E.T. Jordan & Sons General Merchandise store at Carter has been operated by the Jordan family for several generations. Carter is located about 10 miles northwest of Yazoo City near the Humphreys County line. It once consisted of a post office, several small stores, and a gin. The origin of the name is uncertain, but it was probably named for a pioneer settler. (Courtesy of the *Yazoo Herald*.)

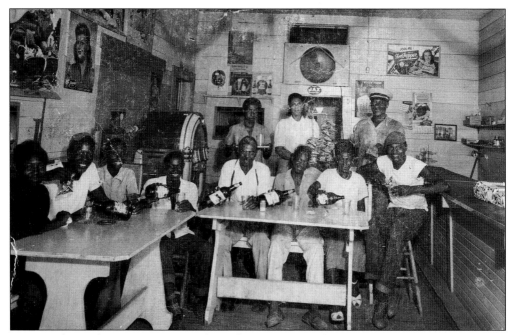

Patrons relax at the Dew Drop Inn in the early 1950s. Pictured standing in the center is Magnolia Washington. Sometimes called juke joints, small cafés such as the Dew Drop Inn were popular gathering spots. The Dew Drop Inn was located on East Commercial Street. (Courtesy of Ricks Memorial Library.)

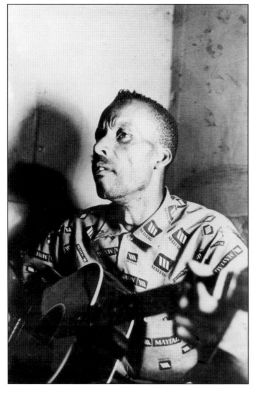

James "Son" Thomas, a blues musician and folk-art sculptor born in 1926 on the Coker place in Eden, Mississippi, played in juke joints in Yazoo City, recorded in the late 1960s, and made festival appearances in the 1970s and 1980s, performing at the White House in 1982. He died in Greenville, Mississippi, in 1993 and is buried near Leland. Son Thomas was one of the last great traditional Delta blues musicians. (Courtesy of the Yazoo Historical Society.)

Mississippi Chemical Corporation, organized in 1948 by 600 farmers, was Yazoo County's largest employer, producing agricultural fertilizers for farmers all over the world. Mississippi Chemical played an important role in the community, supporting charitable efforts, local schools, the library, and other projects to better the lives of the people of Yazoo County. (Courtesy of Ricks Memorial Library.)

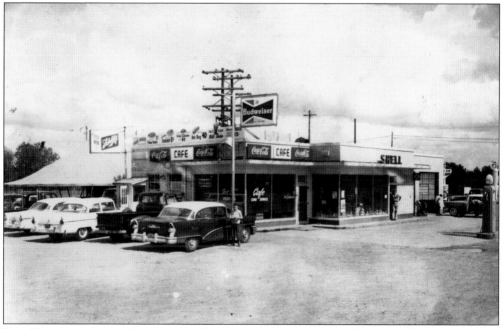

Four-Point Drive-in was the most popular place in town to get a drink or something to eat in the late 1950s. Before and after ball games, parades, or the movies, it was always a favorite. Carhops brought orders to customers' cars from 2:00 p.m. until midnight. Now called Ribeye's, it is still in the same location. (Photograph by Stanley Beers, courtesy of Ricks Memorial Library.)

The Main Street Stationer

VOL. XVI YAZOO CITY, MISSISSIPPI NO. 9 / NOV./DEC. 1996

We'll Miss You!

Henick Auto Supply closed the doors of its historic building on South Main Street as of NOVEMBER 19, 1996.

•

The business itself is about as historic as the building. Henick's had been serving Yazoo City for 75 years!

•

And more than just in auto supplies and similar goods. For many, many years they let Santa Claus come in every Christmas and play the organ or perform other tasks in their front window. Everything moved and delighted kids and adults alike.

•

We ran a picture of Santa in their window on the front of the December 1993 MSS. We're doing it again just to say goodbye to Henick's Auto Supply. The Henicks better stay here!

Christmas . . a time to thank God for sending His son that we might have everlasting life

Christmas . . a time to enjoy our families and see the joy that Santa Claus brings to children

Christmas . . a time to share with others, especially those who are needy, are less fortunate

Christmas . . another time to "say some warm words"

May your Christmas be filled with all the joys promised, all the satisfaction earned, all the blessings of the season.

FROM ALL OF US AT MIJO

In an undated photograph from the 1950s, the automated displays at Henick's Auto Supply on South Main Street at Christmas delighted young and old. Henick's was located in the old Wash Rose building, which dates from the 1870s but has an Art Deco 1930-era addition to the side. (Courtesy of Mary Jones, the *Main Street Stationer*.)

The members of the Barbour family photographed in 1956 are, clockwise from left: Mrs. LeFlore Johnson Barbour and sons Jeppie, Wiley, and Haley Barbour. Jeppie Barbour was elected mayor of Yazoo City in 1968 at the age of 27, the youngest in recent history. Wiley Barbour became a successful attorney with Henry, Barbour, and DeCell. Haley Barbour was elected the 63rd governor of Mississippi, serving two terms from 2004 to 2012. The Barbours are descendants of Mississippi governor (1822–1825) Walter Leake and also of Benjamin LeFlore, brother of Greenwood LeFlore, who sold the land that became Yazoo City. (Photograph by Stanley Beers courtesy of Ricks Memorial Library.)

Six

Vanishing and Lost Yazoo

Yazoo has lost some of its architectural heritage to progress, natural disasters, war, and the ravages of time. At one time, practically every crossroad in the county would have had a country store like this one near Little Yazoo. Sitting under the shed roof is the store's proprietor, Wash Kirk, in a photograph taken around 1950. This store lasted until Highway 49 was broadened into a four lanes. (Courtesy of the author.)

This Yazoo & Mississippi Valley Railroad depot was built before the turn of the 20th century, probably around 1890, in Bentonia, Mississippi. Purchased in 1992 by a railroad aficionado, the train depot was lifted from the spot it had occupied for so long and moved to a new location in Gluckstadt, Mississippi. (Courtesy of Wayne Neal.)

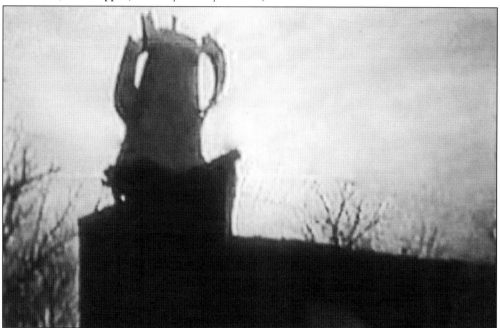

For many years, a huge metal coffee pot atop an old building was a landmark of downtown Yazoo City. This was above Jenne's Tin Shop on South Washington Street. George Jenne advertised in the 1890s that he sold stoves, hardware, and tinware. Roofing, guttering, and repairing were his specialty. The pot, along with the building, was demolished in the 1960s. (Courtesy of Louis Williams and Charlene McGraw.)

Shotgun houses were once abundant throughout the county but are now almost all gone. The most common and popular type of folk-architecture housing in the South from the Civil War until the 1920s, they were so called because the rooms lined up and it was said that one could shoot from the front door all the way through and out the back. (Courtesy of Ricks Memorial Library.)

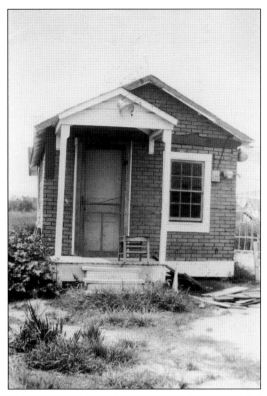

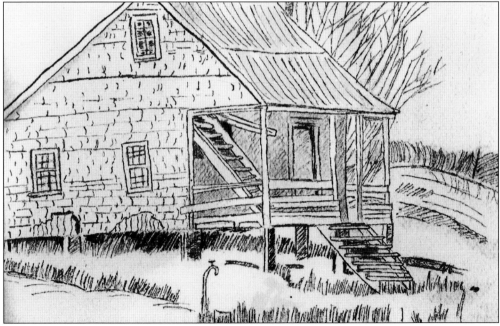

A style of folk architecture reminiscent of Louisiana houses is exhibited by this cabin and several others located near Holly Bluff. The structure was basically a shotgun but with an outside staircase leading from the front porch to an attic room. They were probably built by Sam Scales for the Sharbrough plantation. (Drawing by Janet Arnold, courtesy of the author.)

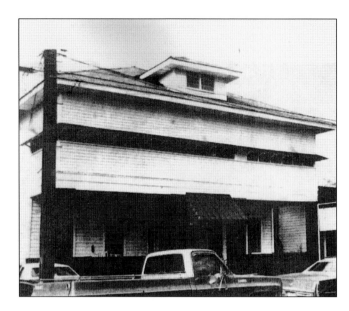

Boardinghouses have become a thing of the past in Yazoo. Marshall St. Romain of Louisiana named the boardinghouse on Mound Street the Creole House. Huberta St. Romain Nelson, known as "Miss Bert," began working there as a cook and married owner St. Romain in 1948. When he died, she married Harry "Red" Nelson. The two-story frame house at times had as many as 35 boarders. The Creole House, now torn down, was well known and fondly remembered by workers all over the country. (Courtesy of the *Yazoo Herald*.)

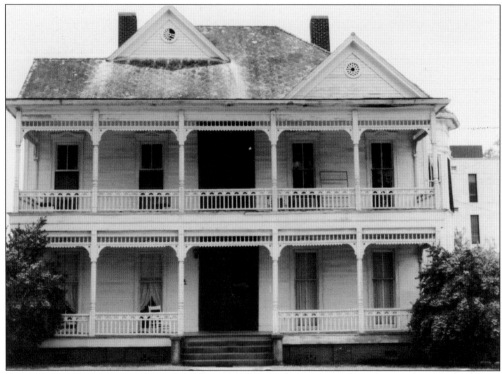

The Edwards house on Madison Street was sold to the county and demolished to make way for a parking lot. This late-19th-century Queen Anne–style house incorporated an earlier house with flush siding on the front, possibly dating from the 1850s. Originally, there was a cupola on the roof, and the staircase inside went up three levels to come out in the cupola. (Courtesy of Ricks Memorial Library.)

The Gardner House, one of the finest and largest of the 19th-century Victorian houses in Yazoo City, was built by A.F. Gardner around 1890. Thick, black smoke billowed from the home as it burned in February 1989. The 5,000-square-foot mansion was the epitome of Victorian architecture and had not undergone any major changes since its construction. Magnolia trees now fill the lot where this house once stood. (Courtesy of the *Yazoo Herald*.)

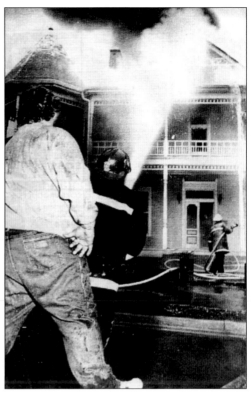

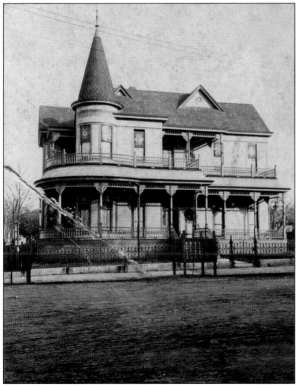

Prior to the fire of 1904, the southeast corner of Broadway and Main Street was occupied by the James house, home of Dr. Dan James and family. His daughter Eula James Colhoun was born here. Dr. James was a descendant of Yazoo County pioneer Peter James (1789–1869), a Methodist circuit rider who built Cypress Plantation just west of Pickens in 1832. Dr. James donated the observatory to Millsaps College in Jackson. (Courtesy of Ricks Memorial Library.)

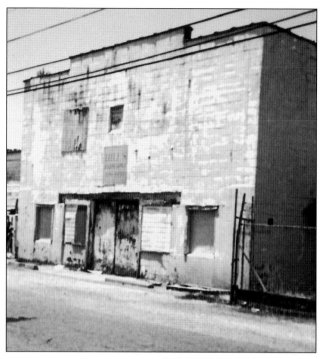

The only black movie theater in town, the Ren was located on Water Street and is still standing, though it closed long ago as an entertainment venue. In addition to showing movies, it also hosted performances by blues artists. When it was known as the Peppermint Lounge, outstanding acts such as Ike and Tina Turner were headliners here. (Courtesy of the author.)

Many changes have come to Main Street over the years, such as the recent revitalization of downtown, but these old buildings on the next-to-last block of South Main are long gone. Taylor & Roberts was a mainstay for Purina Chows, and located on the second floor, "high above the Taylor and Roberts building," was the radio station WAZF. Next door at the time of this 1955 image was Harris Seeds. Later, this building would house Stricklin Furniture Store, and later still, Leo's Shoe Repair. At the time of its demolishment, this was the oldest building standing in downtown; in the 1860s, it had been the Confederate hospital. (Photograph by Stanley Beers, courtesy of Ricks Memorial Library.)

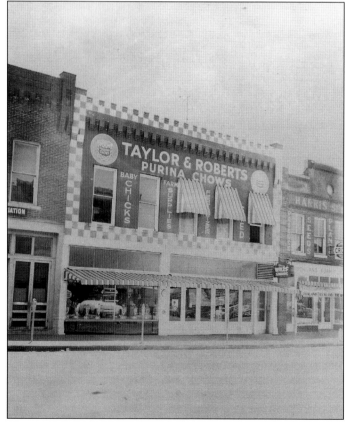

Susie Malone DeVoto sold her movie houses, the DeVoto and the Yazoo, to Dixie Theater Corporation of New Orleans in 1938. The Dixie closed by the end of the 1950s. Pictured here, the Yazoo Theatre, originally an opera house, burned in the early 1950s, reopened in 1963, closed for good in the mid-1970s, and was torn down. The Palace Theatre burned on the night of December 31, 1959. The Ren on Water Street, where famous bluesman Tommy McClennen used to perform, is still standing. McLennen would walk the nine miles from Wilton Plantation into town to play the blues. (Courtesy of the *Yazoo Herald*.)

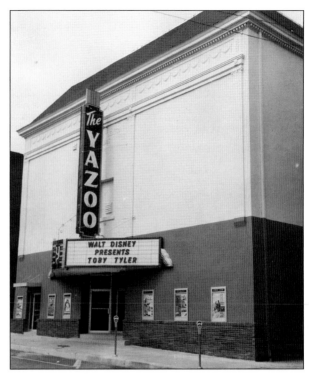

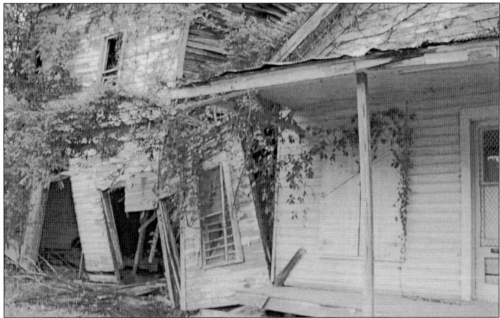

Once a small village, Vaughan, Mississippi, has now taken on the appearance of a ghost town with its few remaining buildings deserted and dilapidated. Vaughan was the site of the famous wreck of the Cannonball Express with Casey Jones at the throttle in 1900. Jones was taken to the nearby Rose Rest, where he died, and the legend of the brave train engineer—commemorated in both a ballad and a postage stamp—began. The legend lives on, but Vaughan is now lost to the ages. (Courtesy of Karen Dunaway.)

DISCOVER THOUSANDS OF LOCAL HISTORY BOOKS FEATURING MILLIONS OF VINTAGE IMAGES

Arcadia Publishing, the leading local history publisher in the United States, is committed to making history accessible and meaningful through publishing books that celebrate and preserve the heritage of America's people and places.

Find more books like this at
www.arcadiapublishing.com

Search for your hometown history, your old stomping grounds, and even your favorite sports team.

Consistent with our mission to preserve history on a local level, this book was printed in South Carolina on American-made paper and manufactured entirely in the United States. Products carrying the accredited Forest Stewardship Council (FSC) label are printed on 100 percent FSC-certified paper.